A BRIDGE FROM DARKNESS TO LIGHT

ALSO BY BILL WRIGHT

The Whole Damn Cheese: Maggie Smith, Border Legend

Authentic Texas: People of the Big Bend
WITH MARCIA HATFIELD DAUDISTEL

*Fort Phantom Hill: The Mysterious Ruins on
the Clear Fork of the Brazos River*

Oman: Land of Diversity

The Texas Outback: Ranching on the Last Frontier
WITH JUNE VAN CLEEF

People's Lives: A Photographic Celebration of the Human Spirit

Portraits from the Desert: Bill Wright's Big Bend

The Texas Kickapoo: Keepers of Tradition
WITH JOHN GESICK

The Tigua: Pueblo Indians of Texas

A BRIDGE FROM DARKNESS TO LIGHT

*Thirteen Young Photographers
Explore Their Afghanistan*

BILL WRIGHT

Fort Worth, Texas

Copyright © 2021 by Bill Wright

Library of Congress Cataloging-in-Publication Data

Names: Wright, Bill, 1933- author.
Title: A bridge from darkness to light : thirteen young photographers explore their Afghanistan / Bill Wright.
Description: Fort Worth, Texas : TCU Press, [2021] | Summary: "In 2006, Texas businessman, historian, and photographer Bill Wright was allowed-though not officially invited-by the US Department of State to teach a class in digital photography to young Afghans in Kabul. The course was sponsored by an Afghan Non-Governmental Organization, ASCHIANA, which helps to support "working children and their families." This book records Wright's experiences and celebrates the creativity he saw flourish at the heart of a war zone. For thirty-five years Wright owned and managed a petroleum marketing company. After selling his company to his employees in 1987, he has devoted his time to writing, photography, and public service on a number of non-profit organizations including the National Council for the Humanities, the Texas Council of the Humanities, and most recently as a commissioner on the Texas Commission for the Arts"-- Provided by publisher.
Identifiers: LCCN 2021034979 | ISBN 9780875657943 (paperback)
Subjects: LCSH: Wright, Bill, 1933---Travel--Afghanistan. | Afghan War, 2001---Photography. | Afghan War, 2001---Social aspects--Pictorial works. | Young photographers--Afghanistan--Kabul. | Afghanistan--Description and travel. | BISAC: PHOTOGRAPHY / Subjects & Themes / Regional (see also TRAVEL / Pictorials) | PHOTOGRAPHY / Individual Photographers / Artists' Books | LCGFT: Travel writing.
Classification: LCC TR820.6 .W75 2021 | DDC 779/.909581--dc23
LC record available at https://lccn.loc.gov/2021034979

All photos are from the author's collection.

TCU Box 298300
Fort Worth, Texas 76129

To order books: 1.800.826.8911

Design by Bill Brammer

CONTENTS

Preface **1**
Chapter One: The Journey **3**
Chapter Two: Arrival **6**
Chapter Three: The First Day—Getting Acquainted **10**
Chapter Four: The Second Day—The First Project **16**
Chapter Five: The Third Day—Portraits and Power Failure **25**
Chapter Six: The Fourth Day—Meeting the NGS Photographer **26**
Chapter Seven: The Fifth Day—Photographing Family **32**
Chapter Eight: The Hospital and Farewell to Kabul **35**
Chapter Nine: Dubai and Heading Home **38**
Photographs by the Afghan Students **41**
Interview with S. I. **125**
Comments from Sarah Johnston **127**
Reflections **129**
Epilogue **135**
Acknowledgments **137**
About the Author **138**

ASCHIANA
Afghanistan's Children- a New Approach
دافغانستان دماشومانو سره دهمکاری (مرستی)مؤسسه

To
Mr. Bill Wright

It is with great pleasure that ASCHIANA accepts your kind offer to provide training in digital photography for ASCHIANA street working children and several Kabul University students. We understand that you will be in Kabul from 23 July until 30 July and that the training will commence on 24 July.

We look forward to welcoming you to Kabul. We understand that you are in close contact with Sarah Johnston. . ASCHIANA will try to assist you with this project in any way possible within the organization's capacity.

Please do not hesitate to contact us through Sarah, our visiting education and training consultant or Rohullah , Technical Advisor to ASCHIANA ("rohullah"<aschiana_cdb@yahoo.com.au).

Please accept our warmest greetings from ASCHIANA and we are looking forward to seeing you on 24 July in Kabul.

Yours sincerely,

Engineer Mohammad Yousef
Director of ASCHIANA

Address: ASCHIANA Next to the Ministry Of Women's Affairs Shar-e-Now Kabul AFGHANSITAN
P.O.Box. 1827 Mobile: #0093(0) 70277280
Email: aschiana@yahoo.com.au Website: www.aschiana.com

Letter to Bill Wright from Aschiana director.

PREFACE

In the spring of 2006, I received an unexpected email from the United States Embassy in Kabul, Afghanistan. The public affairs officer there, J. B. Leedy, wanted to know if I was planning a trip to the area in the near future. The email continued by explaining that the embassy could not invite anyone to Afghanistan as it was still in a war zone, but that should I be interested in coming anyway, she wondered if I would volunteer working with an Afghan NGO to teach digital photography to some Afghan "street working children" who now make money for their families doing a variety of jobs from shining shoes or selling gum to washing car windows.

In Kabul, J. B. had been discussing with Richard Baltimore, the former US ambassador to Oman, the problem of the thousands of street children roaming the streets. Baltimore had recently been transferred to the embassy in Afghanistan. He gave her my contact information and suggested she contact me because of my successful work with the Department of State's Art in Embassies Program.

The possibility of visiting a country that had always been on my list of interesting places to visit and the chance to do a public service photography project made the decision an easy one. Afghanistan is indisputably fascinating. It has been a focus of conflict for centuries, occupying a central position in the geography of central Asia. Over two thousand years ago, Kandahar was a key stop on the ancient Silk Road linking Asia from the eastern edge of the continent to the west. In the early part of the nineteenth century, Afghanistan was in the middle of the "Great Game" between westward-expanding Russia and British-occupied Kashmir. Since then, Russian interest never flagged, and on December 27, 1979, Soviets invaded Afghanistan, streaming through the famous Khyber Pass and occupying the country until they were defeated in April 1989 by the resilient Afghans with the puppet Russian-backed government thrown out. The vacuum left by the Russian withdrawal culminated in a savage civil war that brought the Taliban, supported by Pakistan and Al-Qaeda, to power. They in turn were subdued but not eliminated by the United States, with a coalition of forces including NATO, after suffering an Al-Qaeda backed attack on New York and Washington the morning of September 11, 2001.

By 2006, with American interest shifting to Iraq, the resurgent Taliban were again on the move. They threatened to retake control of the country and reimpose their severe Sharia religious law, limiting the rights of women and punishing all who deviated from their strict interpretation of the Koran. I figured this opportunity to help young Afghans might be my last chance to see some of their homeland.

I wasted no time in contacting Aschiana, the NGO that J. B. Leedy wanted to assist. With the help of an Australian volunteer, we devised a program that could, within the space of a week, give the students a working knowledge of digital photography. [See http://www.aschiana.com.]

The organization maintains seven campuses around the Kabul area and works with three thousand students who receive a healthy meal and training in a variety of areas. It was anticipated that training in digital photography would enable them to leave the street work and secure more appropriate jobs. The US Embassy agreed to donate the necessary computers and digital printers.

Though friends and family urged me not to go, I felt that Kabul was relatively safe at the moment. What's more, the opportunity to visit this incredible country with their ancient tribal customs and to aid young people who had known so much war was irresistible.

Today I am looking at Afghanistan with history unfolding in front of me. My friends at Aschiana are at a great risk. The United States announced their intention to withdraw all their forces, with NATO partners forced to follow suite. As I write these words, there is a mad scramble in Kabul to load all Americans and Afghans who have worked for NATO as interpreters into both military and conscripted commercial airliners. I do not know what the outcome will be. I do know that the students at Aschiana must be terrified. The breath of freedom is a viral experience, and the women in my class were thrilled to be able to expand their knowledge and opportunities. I worry about how I could help my Afgahan friends that remain in the country. I have not contacted them for fear of tagging them to the Taliban; I know, however, that my trip was not in vain, as the following pages will demonstrate. I do not know what is to come in Afghanistan, but know there are thirteen young Afghans who know what freedom is like—and that is hard to forget.

CHAPTER ONE

The Journey

On Friday, July 21, I headed toward the Abilene Regional Airport with thirteen digital point-and-shoot-cameras and other supplies donated by friends in Abilene and across the country. I boarded an American Eagle flight to Dallas, beginning a series of connecting flights for the long twenty-six-hour trip to Kabul.

Fortunately, I was able to upgrade to business class for the Dallas to Zurich leg and spent the time reviewing my scant knowledge of Kabul and working on my course curriculum. The students I would be working with had already participated in some introductory photographic training, and some even had experience developing their own photos and exhibiting them in a public show. However, they had no experience with digital photography, so I knew I had to begin with the most basic information that would enable the students to operate the digital cameras. As the days passed I would introduce various concepts in response to the work they turned in after the first day's shoot. As my flight rushed East toward nightfall, I did my best to put my notes aside and get my mind into sleep mode. I knew I wanted to arrive as rested as possible because my plan was to start the instruction with intensity and maintain it for the week I would be there.

I arrived in Zurich Saturday at 7:50 a.m., Swiss time, a little bleary-eyed from the overnight flight. The Zurich airport was clean and modern, and after a wait till 12:45 p.m., I boarded an American Flight operated by British Airways to Dubai, one of the seven United Arab Emirates. The map showed a direct route across southeastern Europe, then Turkey, Syria, Iraq, Saudi Arabia, and on to the Gulf. We arrived in Dubai, the United Arab Emirates global hot spot, at 8:45 p.m.

On the last travel day, with no sleep and a bit of nervousness, I found the aisle seat on Arab Air flight G90283 to Kabul from Dubai. My seat mate, a Pashtun from the south of Afghanistan and the ancestral home of the Taliban, immediately began silent prayer after we squeezed into the tourist-class Airbus seats. That was understandable, considering he didn't know how to adjust his seat belt. It must have been his first trip aboard an airplane.

In flight, the attendant offered me a sharma bun for $4.00 US, and having had scant fare the preceding days, I jumped at the chance. The man seated across the aisle, who worked for the UN World Food Project, bought one also. In my haste to satisfy my hunger I had eaten the entire thing when I realized that the UN food expert had taken only a single bite before rewrapping the rest. "Dieting?" I enquired. "No," he shook his head. "Didn't taste right."

Kabul is a long way from Abilene, Texas. I had hoped for an uneventful trip and week ahead. After changing planes three times, traveling for the better part of three days, then eating problematic food, I felt like a certified "road warrior."

As we began our approach into Kabul, a moderate dust storm buffeted the plane. It pitched and swerved as the wind seemed to come from all directions. Even being a civilian pilot myself, I was a bit unerved. I leaned across the Pashtun seated beside me to glimpse dark-crested Afghan desert mountains stenciled against the light tan of desert. I could not see the runway. The pilot, dipping one wing, crabbed firmly into a crosswind. Near the ground, the visibility seemed better, but the touchdown was bouncy with the plane skidding and lurching to moderate taxi speed. I found myself checking out the emergency exits.

All in all, it was a skillful landing, and as we taxied toward the terminal I watched an unfolding panorama of ancient and modern aircraft parked on the ramp. There was a preponderance of helicopters with tarps over windshields and rotor hubs to protect from the wind and sand. The buildings seemed to be made of ancient adobe with metal sheeting covering gaps in the plaster. Perhaps they were holes in the structure from previous hostilities. There was an absence of paint in many places, rendering the structures shabby or modernistic, depending on the mindset of the observer. For me, the buildings were not inspiring when compared to the ultra modern terminal I encountered in Dubai.

We deplaned, filled out entry cards, and passed through customs to the luggage area. The ancient conveyor belt struggled with all sorts of weighty packages wrapped in plastic and tied with ropes. There were bags of every vintage and description, a kaleidoscope of color and form contrasting with the somber, crudely constructed terminal itself. The creaking and lurching of the belt stopped, eliciting a concert of groaning from the crowd during the ten-minute delay that ensued while some repair was being made or the electricity restored.

I felt a tap on my shoulder. "Are you Bill Wright?" a bouncy young Australian voice inquired. Turning around, I was immediately captivated by an infectious smile and responded gratefully "Yes!" It was Sarah Johnston, my contact from Aschiana. I was wondering how I would ever find her in

the tightly packed crowd. Standing beside her, trim and youngish-looking, was F. H., whom the US Embassy had recommended as a knowledgeable "fixer." He was a dependable local man who could cart me around for the week and serve as my interpreter, my ticket to communication with the non-English-speaking students.

F. H. had already proven himself a good choice. Earlier that morning, after he had picked up Sarah and started to the airport alarms signaled a bomb threat, and the road to the airport and several major traffic circles were closed. F. H. skillfully rerouted the van along back roads, enabling him and Sarah to arrive at the airport on time. An improvised explosive device (IED) had exploded near the US Embassy and several that did not explode were discovered on the road leading in from the airport. A live bomb was later found in a trash can along the route, and not in the US Embassy as a circulating rumor suggested. I was beginning to think my family and friends had given me good advice not to take this assignment. Fortunately, it was the last disturbance to take place during my weeklong visit that might have affected me.

CHAPTER TWO

The Arrival

We loaded the bags and headed toward my hotel, stopping only to offload the cameras and other equipment at Aschiana's headquarters, where the US Embassy staff had already delivered the needed computers and a digital ink-jet printer. I met several students and some of the Aschiana staff.

As we departed for the hotel, it was exciting to see the mix of nationalities that choked the sidewalks and streets. Colorful. Active. Like a primitive living organism. Beggars at street corners, shouts of workmen. Women in Western clothing mixed with those shrouded in black, peering at the world through black masks. Sounds of traffic. Long, black, shiny Mercedes autos purring ostentatiously amid a sea of sand-colored Toyotas. I was soaking it all in as fast as I could.

We continued to the Serena Hotel and found it heavily fortified. The entrance to the hotel led through a car trap where security personnel raised and lowered steel beams to prohibit either entry or departure while they moved a tilted mirror around the bottom of the car, inspecting for bombs or prohibited items.

Cleared, we passed into a motor court where we unloaded my luggage and registered. I was required to pay for the room in advance. The Serena accepted cash only, a policy I imagined was the result of past experience. The exchange rate was 1 to 49, and they readily accepted my US currency. After making plans with F. H. to pick me up the next morning, I went directly to my room. It appeared comfortable, and the shower, which I tested as soon as I was alone, worked beautifully.

Sarah made plans for dinner at the hotel that evening. Her husband, Mark, would be a bit late, but would join us in time to order. She had also invited J. B., the Department of State public affairs officer who had initially contacted me.

Mark was employed as a policy consultant for the Afghan government on a British project trying to tackle the drug problem. The cultivation of opium-producing poppies created an enormous cash flow into the country, and the UK and US governments were trying to replace it with alternative crops. Both native Australians, Mark and Sarah had reinvented

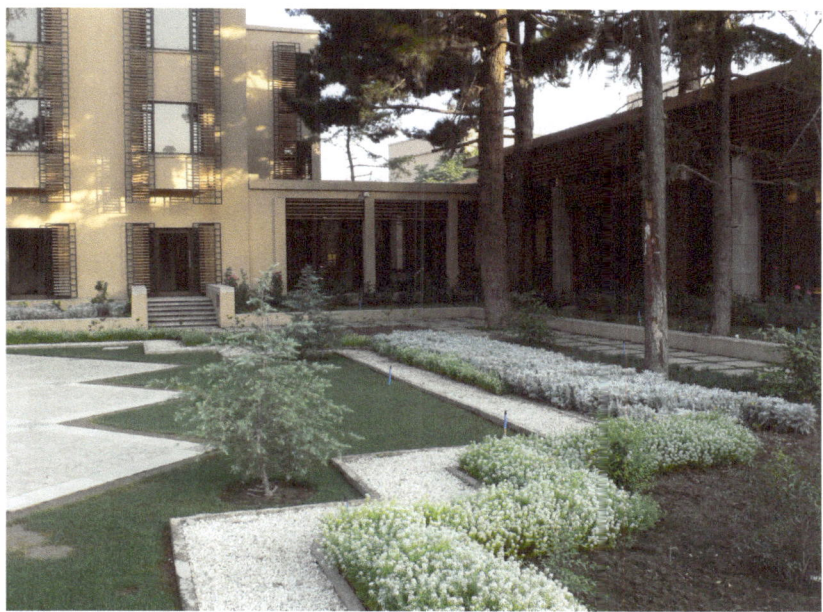

Courtyard of Hotel Serena.

themselves, leaving their public sector jobs, sailing to Thailand on a thirty-three-foot boat, and then starting work as consultants, Mark in the field of government policy work and Sarah in education and training. Mark had spent four years at Harvard at the Kennedy School and was awarded a PhD in public policy. Their current, permanent home was in Bangkok, but they saw little of the city with their journeys from one assignment to another. (Their next would take them to Ulaanbaatar, Mongolia.) Sarah had always been successful in obtaining employment teaching English and in exercising her considerable management skills on behalf of nonprofit organizations.

I met Sarah and J. B. in the lobby at 7 p.m., and we proceeded to the hotel restaurant to wait for Mark. I soon found that the "J" in J. B. stood for Jean, and that she was as passionate regarding her job as her email indicated. She and I discussed the roles of public affairs officers in conflict areas. She found it frustrating that embassy personnel were prohibited from circulating freely in town, which made the cultural affairs component of her responsibility much more difficult. While interpreters were certainly employed by the embassy, they were not always available, and because it was a war zone, J. B.'s ability to mix and mingle with cultural

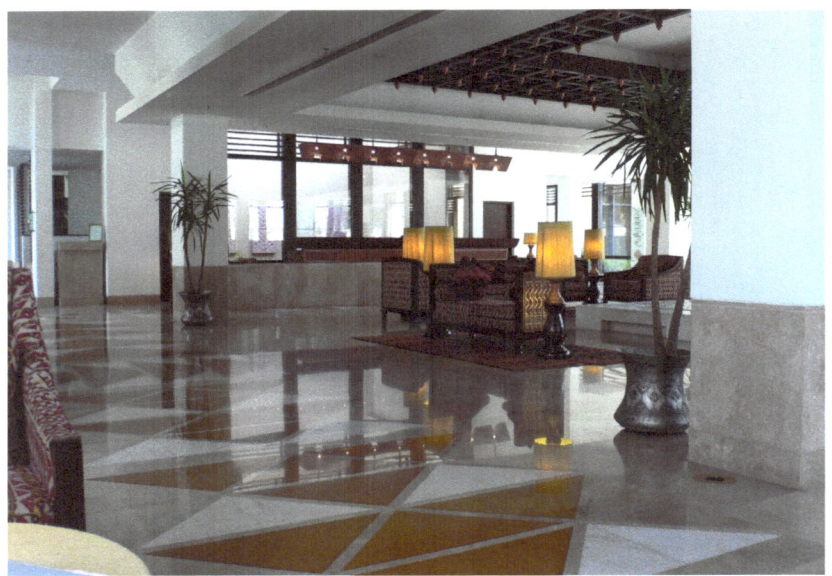

Lobby of Hotel Serena.

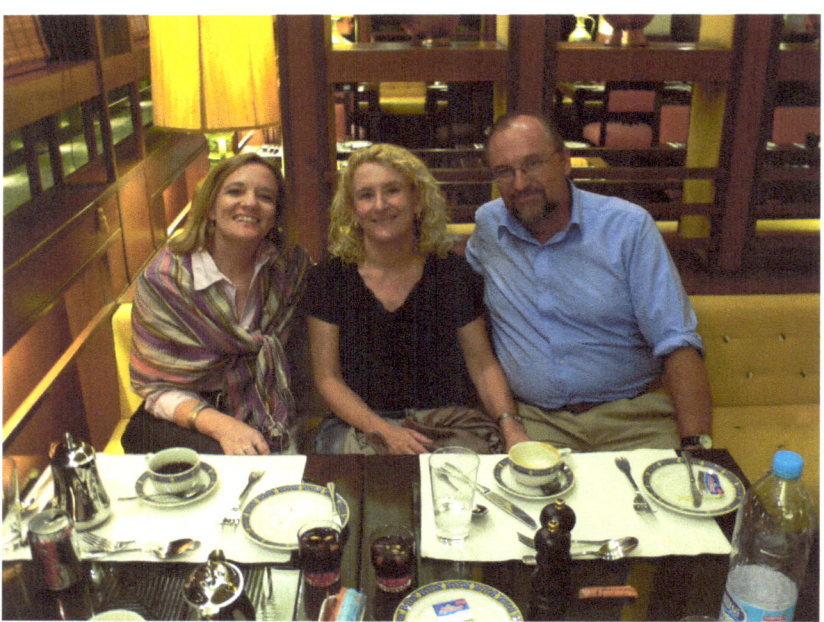

J. B. Leedy, Sarah and Mark Johnston at dinner at the Hotel Serena.

groups was restricted. In addition, her actions were further complicated by religious restrictions. The Western culture that had pervaded the Arab world did not find favor with the more traditional Muslims. Western music was too suggestive, dress too provocative, and on top of that, the more conservative Muslims believed women should not be seen in public at all. J. B. related her duties and the opportunities to create cultural activities in Kabul, and I was amazed at the responsibilities she shouldered with so few resources available to her. She attended public cultural events representing the US government and supported many cultural and nonprofit Afghan organizations with grants. I immediately believed that she was certainly a worthy representative of America to the people of Kabul. J. B.'s husband, a military officer, was assigned to the Pentagon in Washington. As a Department of State employee, J. B. had the option of one year of solo duty in Afghanistan without her husband, or two years solo at another more friendly and enjoyable location. She chose the one-year separation.

There were no cocktails before dinner, as Afghanistan is a Muslim country, so J. B. and I enjoyed a Diet Coke, and Sarah chose a local melon drink. I thought I might try the melon drink, but she advised me against it to ensure I would continue to be "fit" for the remainder of the week and not cut down by "the Taliban's Revenge."

Mark arrived a short while later and with typical Aussie style pulled up a chair next to mine. His friendly and engaging personality instantly set me at ease, and I appreciated his informed candor regarding Afghanistan and the opium trade that made up so substantial a percentage of its gross national product and helped finance the Taliban. It would be no small task to provide poppy farmers with a lucrative but legal alternative.

Our discussions continued through a delightful dinner of Australian lamb until it was time to head for bed. It had been a long but interesting day.

When my hosts departed, I returned to my room and jotted down some notes and names. Even after almost twenty-six hours of travel, a big dinner, and comfortable air-conditioning in the room, I was so excited it was difficult to relax. After running through the days' events several times, I finally drifted off sleep, wondering what adventures tomorrow would offer.

CHAPTER THREE

The First Day— Getting Acquainted

I awoke early on Monday and at 6:00 a.m. I was in the lobby to get an ethernet cable for my laptop and a quick breakfast. With the cable installed, I downloaded over two hundred emails, many from friends wishing me the best of luck on my journey. F. H., my driver and interpreter, was scheduled to meet me at 7:45 a.m. for the trip to Aschiana. I wanted to get the computers set up and ready for action after lunch.

F. H. was prompt and swiftly introduced me to my first real experience of driving in Kabul traffic. By comparison, traffic in Cairo a few years ago had been a snap. Our trip to the school was mercifully short, but in the space of only a few miles we narrowly escaped at least a dozen collisions. The condition of the vehicles we passed suggested others had not been so lucky. Amid a blur of color and motion, scowls and gestures, horns blared; the rules of the road were undecipherable. I asked F. H. if the number of toots on his horn, one toot or two, sometimes three, meant something specific to other drivers. He confirmed that it was a generally understood code. One beep was to announce a person's presence, a couple indicated we were passing, and three demonstrated impatience without the international visual symbol. Compounding the confusion was the lack of traffic lights. Few had worked since the Taliban were routed from the city during the days of the American arrival in 2001. Somehow traffic continued to move, although with the informal signal system.

F. H. was nonchalant. He chatted easily, inquiring about my family and life in the United States. We talked about the troubles in Afghanistan and the rest of the world. He was born in Afghanistan, but he left for Pakistan when the Taliban took over. After the war he returned and hoped that they would never come back. "Enemies," he said, "continue to surround Afghanistan." Pakistan, a nuclear-armed country, was considered the most serious threat, always seeking Afghanistan's rich mineral resources. He was also worried about Pakistan's internal stability because only its capital was secured, with radicals controlling the countryside despite the army's efforts. In addition, Iran presented another threat—a constant source of

infiltrating fighters who passed through Afghanistan enroute to Iraq, Palestine, Pakistan, and other Arab countries, destabilizing them.

We arrived whole at the school, and shortly Sarah met us there. This was to be the big day—distributing the cameras and working with the students to make their first photographs. I was anxious to get the computers set up and ready for the students so they would be able to see some results from their cameras immediately.

There was one small problem. The classroom containing the computers and cameras was locked, and no one could locate a key. Sarah, a model of efficiency and persuasion, determined that the office manager was ill at home, and she was able to roust him from his sickbed long enough to dispatch the key.

While waiting for the key, I took the opportunity to visit some of the other Aschiana classrooms. I was amazed at the quality of the artwork of the students. Art is very important in Islamic cultures. Originally, fearing idolatry, religious leaders forbade depicting the human form or other living figures. Consequently, Islamic art developed geometric and floral designs that students are trained to master. Contact with Western traditions has moderated this prohibition in recent years, but these patterns remain popular and traditional.

My class began filtering in at nine o'clock, and some were late. When they arrived, Sarah laid down the law. Tardiness would not be tolerated. Also, no certificate of completion would be awarded to anyone who was not in attendance for the entire week. I did not hear a single whimper in response. We started with introductions and soon transitioned to explaining the functions of the new cameras. I was worried about being able to communicate adequately and hold the student's interests. I need not have worried. Efficient Sarah, assisted by F. H., kept everything on track. The class was eager and fully invested in the prospect that what they would learn would increase their earning power by enabling them to photograph weddings and other events for pay. My baker's dozen of students ranged in age from twelve to twenty-six—the three oldest attended the University of Kabul. Prior to my workshop, many of the students had first met in a joint photographic project linking students from both the University of Kabul and Aschiana. Both boys and girls had participated. After a successful exhibition at the University of Kabul, they asked Aschiana and Sarah (who had just joined Aschiana) to hold a second exhibition of the photos they had taken and developed. Most of the students who faced me on this first morning had participated in this earlier training, and their successful exhibition was supported by the expat community. The students submitted a written application explaining why they should be included in my digital photography program, and Aschiana made the final selection.

We began with introductions and soon transitioned to explaining the

functions of the new cameras. One of the university students, S. I., could speak some English and worked with the non-English-speaking students.

S. I. had been one of the previous exhibition coordinators and the male team leader for that project. He took his role seriously. Sakina, the sixteen-year-old team leader from the other project, was also a great help. She had come through Aschiana's street kids' program and was also known locally as a talented actress as well as a good photographer. As in early one-room American schools, the range in ages turned out to be an advantage, with older students assuming some responsibility for aiding the younger ones. The original concern that I had harbored about the age range of my students vanished completely. It was not a problem. All of the students were anxious to learn. The morning passed quickly.

There was time for the students to examine some of the materials I brought with me. They had already received copies of the National Geographic Society's newest book on digital photography through the assistance of Sue McKeon, at the time the director of Abilene's National Center for Children's Illustrated Literature and a former *National Geographic* employee. They flipped the colorful pages looking at the pictures while F. H. circulated around the room explaining some of the texts. Finally, the time had come to hand out cameras and demonstrate the basic functions. When the cameras were handed out, the students immediately turned to the person next them and took a picture. On reflection, I thought this an understandable reaction because in their devasted country, only some of their friends remained.

There were many questions about using the cameras that Sarah, F. H., and I tried to deal with so that the students could make a few photographs before lunch. They ran out of class taking photographs right and left.

At lunch I joined the students in one of the galleries where they gathered with their plates of food from the Aschiana kitchen. The school served all the students a healthy lunch of rice and vegetables. There was a lot of chatter about the cameras and the pictures they had already made around the campus. As appetizing as the lunch appeared, I resisted for fear of a GI upset and settled for a granola bar from home. After lunch we reassembled for final instructions regarding the afternoon activities. I assigned no specific subject matter, hoping the students would merely get well acquainted with the cameras, and off they went with great excitement. While they were making photographs, F. H., Sarah, and I finished hooking up the computer lab and installing the processing software that I brought from the United States. When installing the equipment donated by the US Department of State, I realized how much we take for granted. Each computer was accompanied with a special power supply to ensure that the computer would not shut off immediately if the generator for the

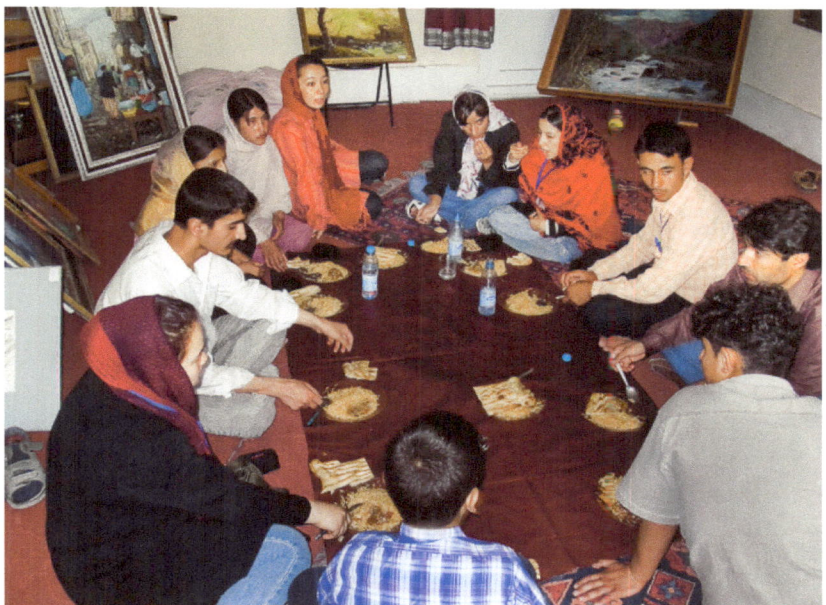

The students ate lunch on the rug with their hands. It consisted of rice and bread and provided lots of calories for them.

building should quit. In Kabul, power shuts off at night. As we assembled the computers, I noticed the power strip had an unburned match jammed into the on/off button. Potentially dangerous. I requested three new power strips so as not to put too much power load on each one. Fortunately, the State Department grant also provided rechargeable batteries for the cameras. I knew the students would be going through AA batteries at a ferocious clip.

Soon the students began filtering back in with full compact flash cards, anxious to see their photos. F. H. was invaluable in assisting with the computer equipment. He had a good understanding of computer operation and was able to assist the students who were not computer literate. I thought it interesting that F. H. left the class several times a day for prayer, but the students did not.

To guarantee that photos would not be mixed up on the computer, we established separate folders for each student and showed them how to download from the cameras directly into them. Then we created a slideshow of each student's work that afternoon and discussed each image as it appeared. It was soon evident that some of the students who had already

F. H.

taken some art and photography classes were more experienced observers than others, but all came back with images.

As I had not given them a specific assignment, it was interesting to see the types of subject matter that caught their interest. Talk about excitement! Seeing their images on the big computer screen made them giddy. We printed some of them off on plain paper and taped them to the wall. Proud is a weak word to describe their elation. The process was an excellent opportunity for me to point out flaws and critique technique at the beginning of the course, in hopes that subsequent efforts would be more successful. The primary problem at this point was camera shake and lack of critical focus. They tended to shoot wildly and not take the time to steady their cameras.

Several of the students were more aggressive than others. S. I., perhaps because he spoke some English, peppered me with questions about

different camera controls and why I thought one view was better than another. I found myself wishing that I could have several weeks to work with them and help them refine their vision and skill. By the time 4:30 p.m. rolled around, I was a bit giddy myself. Fatigue had overpowered enthusiasm, and I was ready to get back to the hotel room and get cool. (Of course, the school did not have air-conditioning.)

Back at the hotel, I slumped down in the room's only stuffed chair and sucked down a liter of water. It had been a good first day of class. I was awed by the artistic sophistication of the students. In Afghanistan, art is everywhere. Even the written language is regarded as an art form in the same way that Japanese characters are honored as much for their intrinsic design as for their message. From their first photographs, mostly of each other, I could see how aesthetically aware these students were of their world.

CHAPTER FOUR

The Second Day— The First Project

The next morning, Tuesday, I awoke thinking about the news item I had seen in the previous day's morning paper. "Taliban attacking Afghan schools." Two hundred schools had been burned or abandoned because of Taliban actions to discourage the secular education of Afghanistan's young people, especially girls. Their educational approach is to study the Koran instead of the Western approach of public schools teaching a wide range of subjects. And, of course women did not need to be educated at all. Yet, after only one day with my students, I found it hard to imagine the young women in the class willing to stifle their intellectual curiosity. I can almost assure you that the young women in our class would go down struggling if they were sent home to bake bread and be the third wife of some ancient tribal leader.

Another disturbing bit of news: the Karzai Administration was considering reestablishing the religious police. Obviously, he was under heavy pressure from fundamentalists. This would be a giant step backward in the modernization of the country. I was not sure this had been reported in the world press, but local news organizations carried the story. I thought about F. H. Even though he was a "reformed" Muslim, he still left the class and prayed during the designated times. It was interesting that the students did not follow that tradition. Perhaps the Mullahs gave students a pass.

F. H. arrived on time, and again we drove into the maelstrom of bikes, vans, pedestrians, and taxis. As my confidence in his driving grew, I began to sound him out on current events. When I mentioned the article about the religious police, F. H. responded that it was not as big a deal as some of the foreign press might think. "All Muslim countries have the religious police," he said, "but their actions were exaggerated under Taliban rule. I don't think we will ever see those extremes again."

I was aware of another report that revealed there had been rapid local actions taken with regard to the bomb blast near the US Embassy the previous Sunday. Several persons had been taken into custody, but I did not

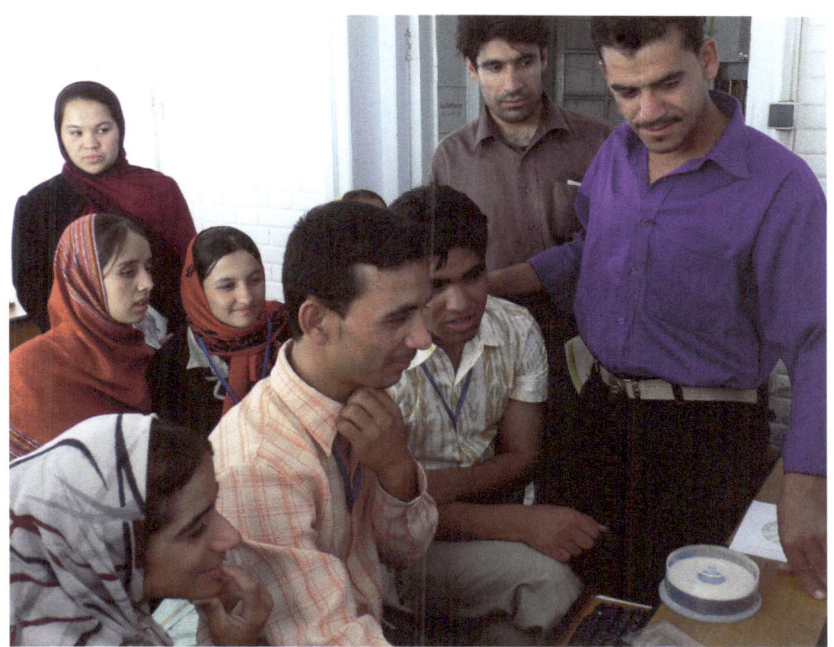

Students viewing their digital images for the first time.

mention it to F. H. I thought it best to discuss these negative reports slowly as I gained more perspective into his life and feelings. At any rate, life at the moment seemed to be calm, going on as usual for these battered people.

As we continued toward school, my thoughts returned to the students. I thought how exciting the previous day had been for them—having the cameras in their hands for the first time and seeing their photographs on the screen. I was excited to see more of what they saw with these new eyes.

We arrived at the Aschiana compound and entered the gate. There were a number of children playing and older students hanging out until their classes started.

Aschiana, I'd found, was well-known in Kabul as a place that catered to children and as a place that was safe. Inside the walled compound of their school, there were always students playing who perhaps would later pose for me. Their progress required both education and opportunity. With access to the internet, knowledge of the world was available to some. Perhaps opportunity would come with stability.

Entering the classroom, I found that two girls had come to the class uninvited and asked to observe. Word was getting around. I agreed and they dove into the work immediately. Their enthusiasm for learning elevated

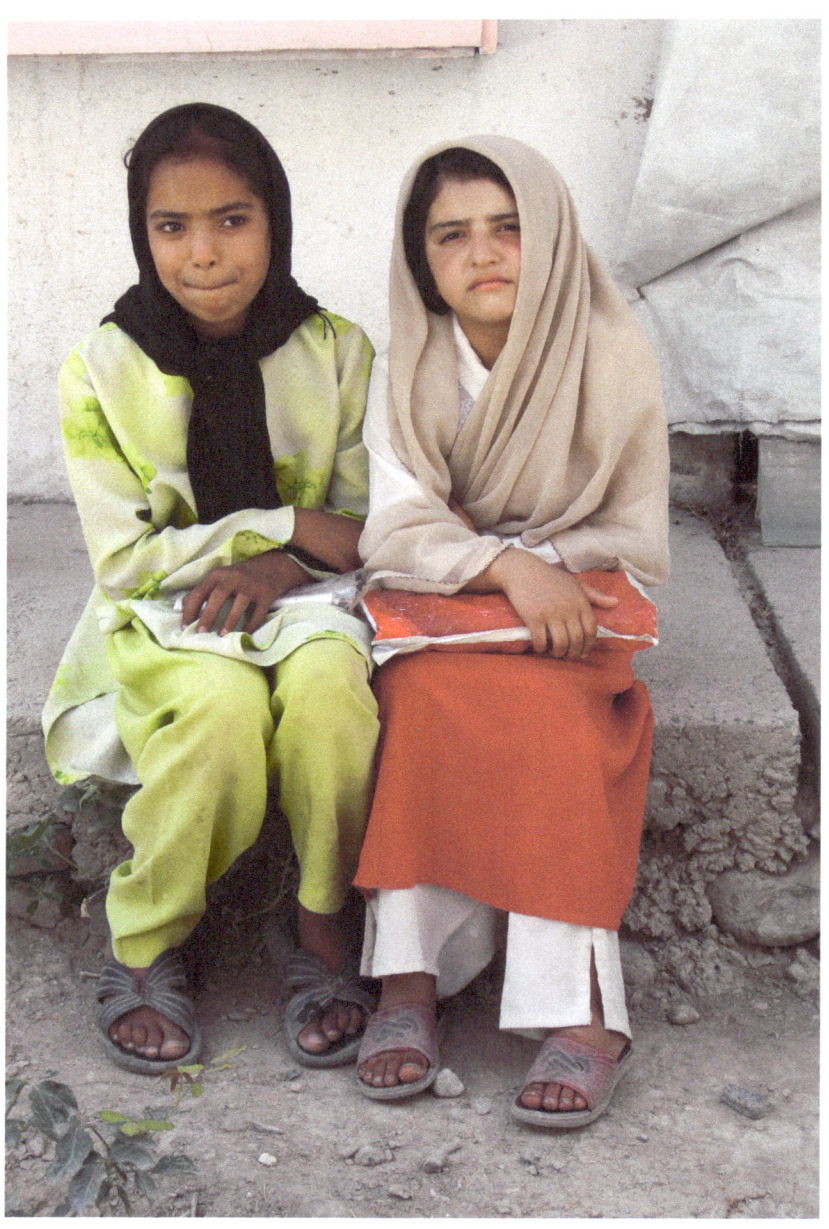
Two Afghan children at Aschiana.

my own spirits and confirmed there is much good in the world despite the disasters that impinged on their daily lives. These young folks—I couldn't call them kids because they grew up fast here—were intent on learning.

My plan for the morning was to connect to the internet and show the students my own website and those of other photographers, but unfortunately, Aschiana's internet connection was not working. When I inquired, I found that Aschiana had not paid the monthly bill because of lack of money. Since most of the students had their only internet access through the school, they were essentially blocked from using it for news and research. It would be reinstated if more money became available for Aschiana's support. I had to realize that progress occurs gradually. The students seemed nonplussed about this, but each interruption made me think hard about what I take for granted at home.

I began the day's class by explaining the best I could the differences between dpi (dots per inch), along with the jpg and tiff file extensions, kilobytes and megabytes, and many other terms they would encounter with digital photography.

We went through the menu of options for the operation of their cameras and talked about histograms and exposure. There were many questions, and F. H. was wonderful with his assistance. In addition, S. I. not only continued to ask many questions, but he shared my answers with the others. He demonstrated the advantage of speaking the same language as the students. Another student began to assume some responsibility. Hashmat Ullah Wardak demonstrated some impressive computer skills and quickly began to help other students who were not familiar with the equipment.

As it was time for lunch, J. B. asked Sarah and me to join her and the embassy's financial agent for lunch at a traditional Afghan restaurant named Safi. It was a long way from the school, and the drive would give me a chance to see more of Kabul. The Aschiana director, Engineer M. Yosef, accompanied us, and F. H. drove.

As we entered the restaurant, Sarah was excited to see a well-known local woman, Nancy Dupree, the author of *An Historical Guide to Afghanistan*, the definitive guidebook for Afghanistan. Her husband, Louis Dupree, a distinguished scholar, wrote a book simply called *Afghanistan* that should be on the library shelf of anyone interested in the country. In his book he observed that Afghanistan is actually a nation of poets because poetry, essentially a spoken language, enables illiterate men and women to express themselves. Nancy looked to be over seventy years of age but sparky, intelligent, and interesting. I photographed her with Director Yosef, who was one of her great admirers.

The meal was exceptional. They tried to stuff me with every traditional dish, but I was careful, especially since Sarah had caught some bug and

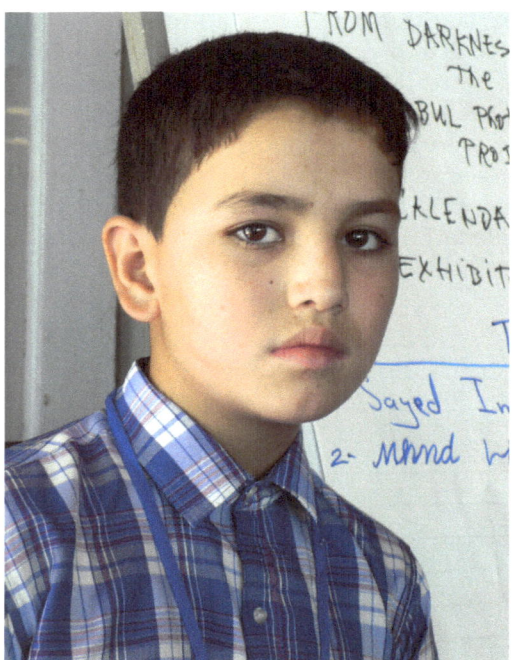

Our youngest student.

was forced to make an emergency stop on the way. My two favorite dishes were the vegetable soup with cilantro and pureed vegetables, and the aushak, a lentils, scallions, and dumpling concoction with a yogurt sauce. A fantastic meal to remember.

Driving back to the school we stopped along the way for me to take a few photographs of my own.

After we returned to the school, we found the students eagerly awaiting their assignment for the afternoon. I wanted them to find and photograph "the beautiful" in Afghanistan. I was interested to see whether their images would comprise a sort of visual poetry that would parallel the written words Afghans love so much.

The students were very much in love with art. They wanted to photograph other artists' paintings because they thought them beautiful. I asked them not to do so. I wanted them to express their own vision, not someone else's. The youngest student, age twelve, as well as some of the others, had taken many pictures of paintings that were made by the art students studying on the campus, but as the day progressed he moved beyond the artists' work to living canvases informed by his own vision.

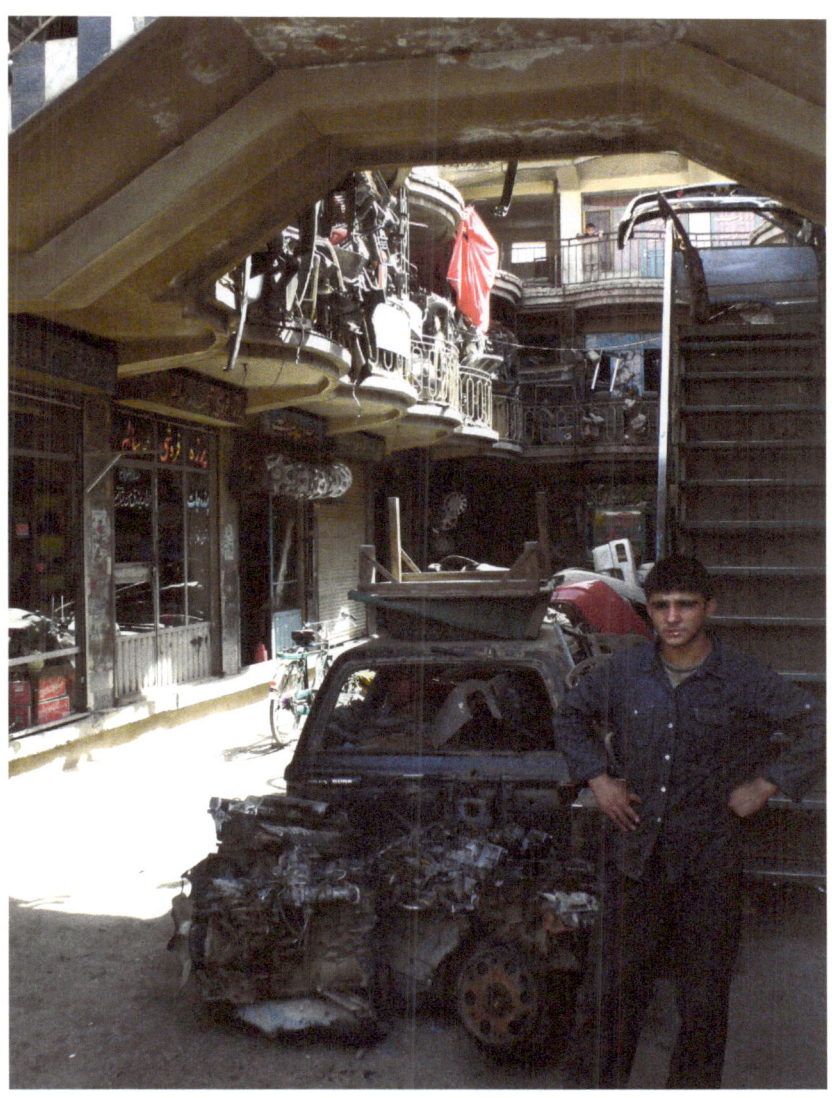

Kabul street scene.

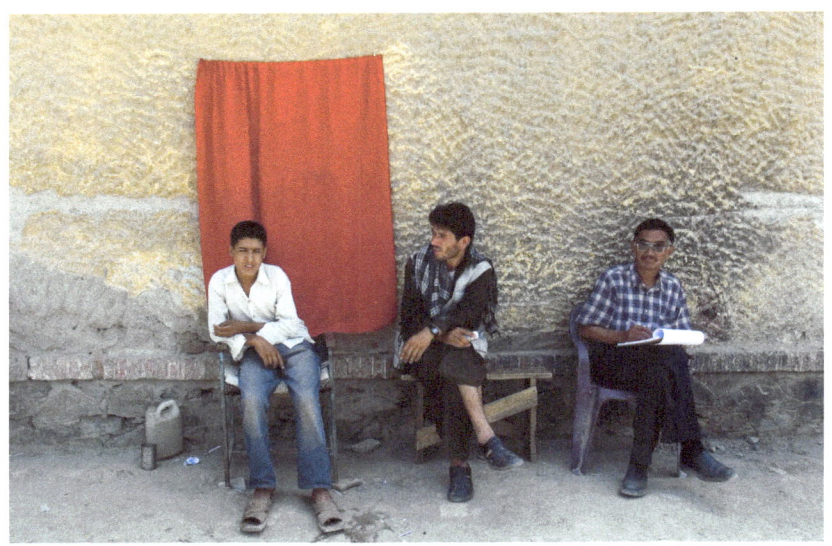

Taking a break outside on the street.

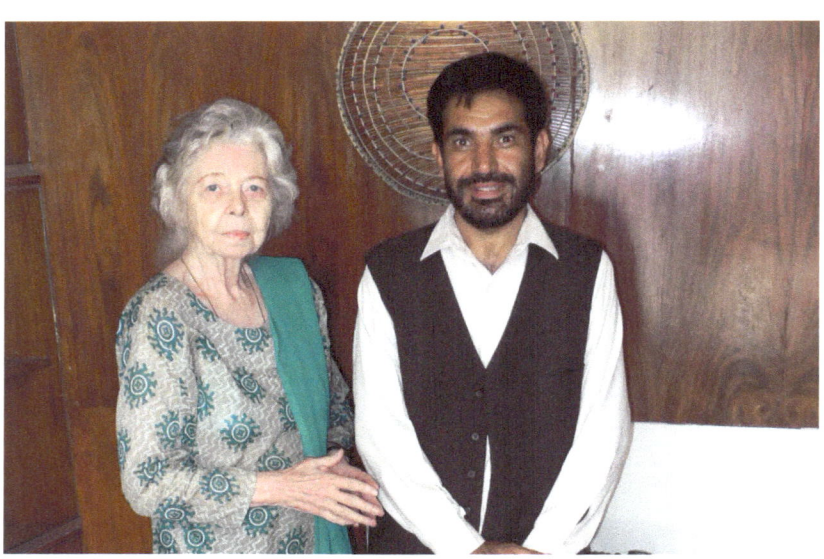

Nancy Dupree and Aschiana director, Engineer M. Yosef.

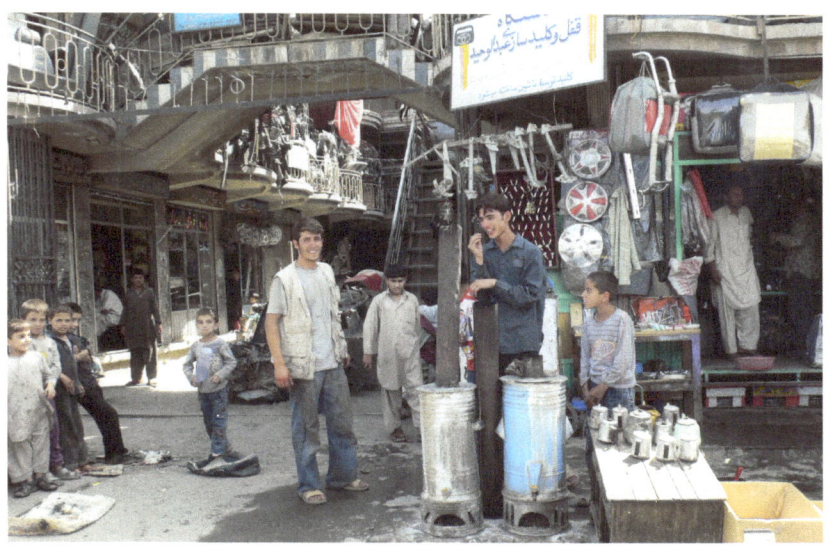

ABOVE AND BELOW
Typical shops along the roadside in Kabul.

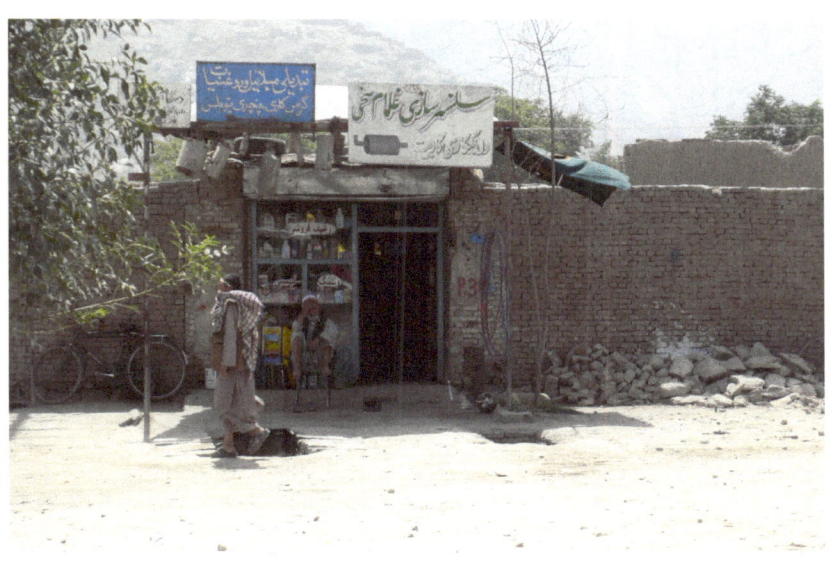

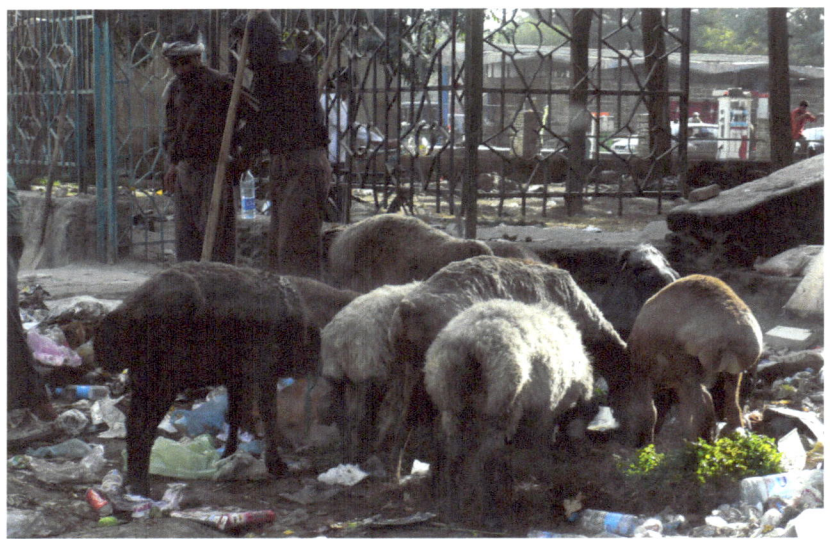

Herdsmen bring their animals with them on trips to town.

There was active discussion going on about the issues of composition and focus we had covered the previous day. Again, S. I. began peppering me with questions: "Why do you get a longer focus when you use a bigger number for the size of the hole in the lens?" We didn't have time to go into the physics of depth of field and aperture settings; I just wanted them to know it worked.

F. H. did a wonderful job assisting in computer work and explaining how it all went together. Later he told me the day was a great success.

By the time 4:30 rolled around, my enthusiasm had been sapped by fatigue, and I was ready to get back to the hotel room and get cool.

CHAPTER FIVE

The Third Day—
Portraits and Power Failure

Today confirmed that I am a slow learner. It has taken three days to understand that my room, 284, is not on the second floor. The lobby area is floor zero, which I understand. When I press 2 on the elevator I get off at the floor where all of the rooms begin with "3." So, the second floor is really the first floor. I think I have it down now. I get on the elevator and press "1" for the floor containing my room, 284. Live and learn, if slowly.

Opportunity is dramatically lacking here in Afghanistan. The internet will give my students more of an opportunity than they have had before. Unfortunately, Aschiana's internet connection has been shut down for lack of money. That will change in time.

But there are frequent interruptions in electrical power, which is shut off completely at night. Energy drives our civilization, and without it we would all be subsistence farmers with only the sun to provide our life.

We had a portrait shooting session where we talked about the light and how important it was to focus on the eyes. I set up and took pictures of the students, and they posed and took turns being the model. Before I knew it, time for lunch. There was a lot of chatter about the cameras and the pictures they had already taken around the campus.

When the students returned later in the afternoon, they rushed to the battery chargers to prepare for the next day, then got in line to load their files on the computer to review. Strangely, the green charging lights didn't come on when we plugged the chargers into the wall outlet. We fussed around trying various plugs, taking out and putting in the batteries, changing chargers, and then realized the power was out. The computer had been running on battery back-up. We left for the night with the hope that in the morning we would have fully charged power for the cameras. The students seemed to take the power interruption in stride. It occurred frequently in Kabul and they were used to it.

Another lesson about life in Afghanistan.

CHAPTER SIX

The Fourth Day— Meeting the NGS Photographer

I woke up to bad news this morning. There was another bomb blast on the outskirts of Kabul about thirty minutes ago. Two persons were killed and a taxi demolished. Four other people were injured. The explosion occurred on a road heavily traveled by the US Military as they travel between one of their nearby bases and downtown Kabul. J. B. had planned to come by early in the morning to meet some of the students, and I hoped this latest incident would not restrict her to the embassy campus. I was certainly grateful for the tight security at the Serena Hotel and my experienced "fixer" F. H. I imagined everyone would be looking over his or her shoulder, which would be good.

Dressing quickly, I went to my laptop and organized by student the photographs I had copied from the class computer. I wanted to see each person's work as a unit, and I planned to add each day's photographs into the appropriate category. This way I could be sure each student was represented in the exhibition I was planning on my return to Abilene. Already the students had amassed quite a number of images, and despite the limited mobility of all but the oldest students, a narrative was evolving. It was their story of Kabul. Indisputable, it spoke to conditions in this poor, riven country, and in strokes of light and color evoked a heritage that clearly spoke to them.

While the students certainly profited from the project, I was the real winner. I came away inspired by the contact with the students, our embassy staff, and the other volunteers working in Kabul. I was awed by the enormity of the task ahead for the country these young people would inherit.

Before breakfast, I walked for a while in the garden of the hotel. The rose garden was in bloom and the doves were flying about. What a strange contrast with the events of violence that are occurring in the country! It was very peaceful, and the sounds of the city coming to life were much the same as I would expect to find in any American city. Of course the similarity ended as soon as I exited the secured gates of the hotel.

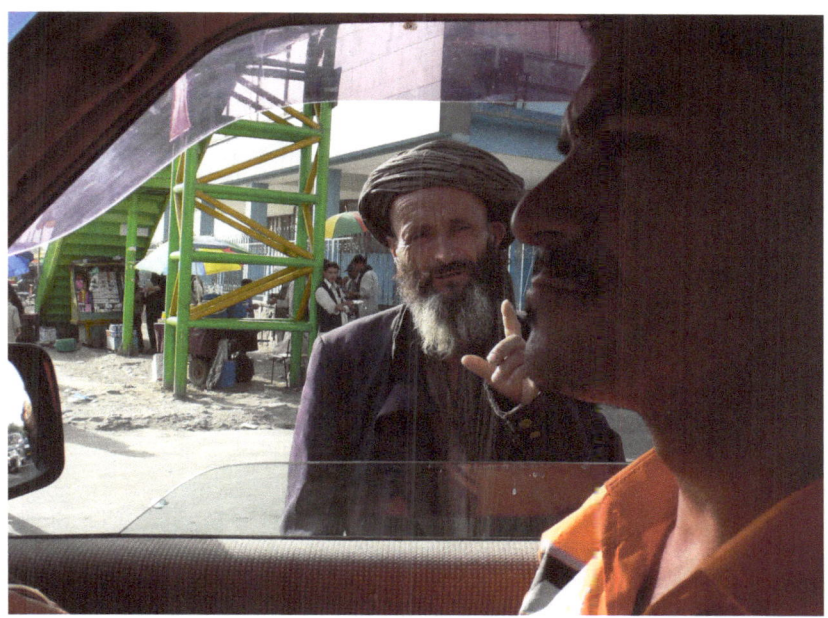

F. H. ignoring a street beggar.

I was looking forward to the day's activities. After J. B. visited the class at Aschiana later in the morning, we planned to take the students to AINA for a party. AINA is a program founded by a *National Geographic* Photographer, Reza Deghati, who assisted my friend, Sue, in securing the books for the students here.

F. H. delivered me to the school and we began to gear up for the trip to Reza's party at AINA that turned out to be a party celebrating his fifty-fourth year.

Before we left, J. B. came by the school to review some of the student work and to take some pictures of them working at the computers the State Department had funded. She arrived about 10:00 am and was very pleased with what she saw. A little before noon we all left for AINA. J. B. drove in her armored vehicle and met us there. She couldn't ride with us because she had to ride in the department's armored Land Cruiser that stood out like the red nose on a clown's face. Certainly, a target. The students, Sarah, and I traveled with F. H. in a nondescript van, one of a thousand of like design scuttling about the streets of Kabul. Every time we stopped for congested traffic, street people would approach us for hand-

The Fourth Day—Meeting the NGS Photographer **27**

outs without success. F. H. never made eye contact—either traffic would start moving or our petitioners would give up and move on to another vehicle.

The organization Reza founded, AINA, is a school dedicated to developing photojournalists and design specialists, and his photographs are hung about the patio. Reza had arranged for a group of French clowns to entertain the assembled guests, including 150 or so children in addition to ours from the school. Knowing of our group's special interest in photography, Reza took us on a personal tour and explained each photograph, pointing out the features that made it exceptional. While I could not understand the language, by his gestures I could tell that he was reinforcing many of the lessons I had already communicated to the students. A lot of pixels were stimulated during the day.

We returned to the school with F. H.'s van stuffed full of students wiggling like popcorn in a popper! Our van was certainly hot enough. Sweat was pouring over me even though the top panel was open. It was about 102 degrees in Kabul, and of course there is no air-conditioning except at the hotel. The students didn't mind. They were laughing and teasing each other and popping about like crazy.

I wondered what would happen if F. H. made a driving error. No seatbelts, of course, and as aggressive a driver as my wife, Alice, considers me to be, I was no match for F. H. My abs will be in good shape on my return because I do the tightening exercise every time he pulls in front of an oncoming bus or speeding motorbike. I wouldn't want to compete with him in a computer game. His reaction time could be measured in milliseconds.

On our return to Aschiana, I began a project with the students proposed by Sarah to make some money for the organization, continued doing the formal portraits of the students for the calendar project, and designed the mats and presentation for the school. The plan is to sell the calendars with the children's photographs to State Department workers as they go home for rotation, and this posting will have about an 80 percent turnover by the end of August. A real problem of continuity. Most people take about six months to settle into their jobs, and by the time they are in tune with the local situation it is time for them to leave. Of course, they are professionals and trained to operate with these kinds of restrictions. More on my thoughts re: our state department later.

We worked hard all afternoon. I photographed each of the students for the calendars and downloaded and viewed images taken at the morning party. I continued reviewing various students' work, photographing and teaching computer skills of file management, and downloading and viewing images. Using the crop tool on Photoshop Elements, I showed how they could improve their images by eliminating extraneous areas.

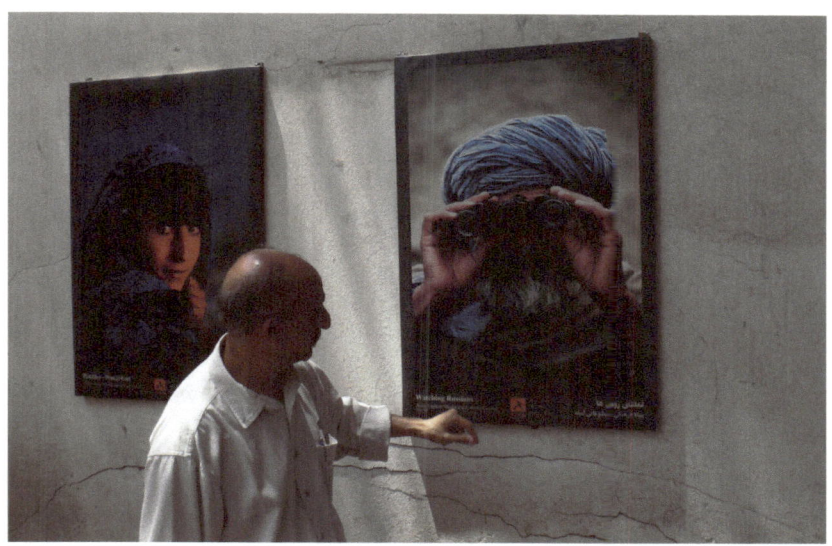

Reza Deghati explaining photographs.

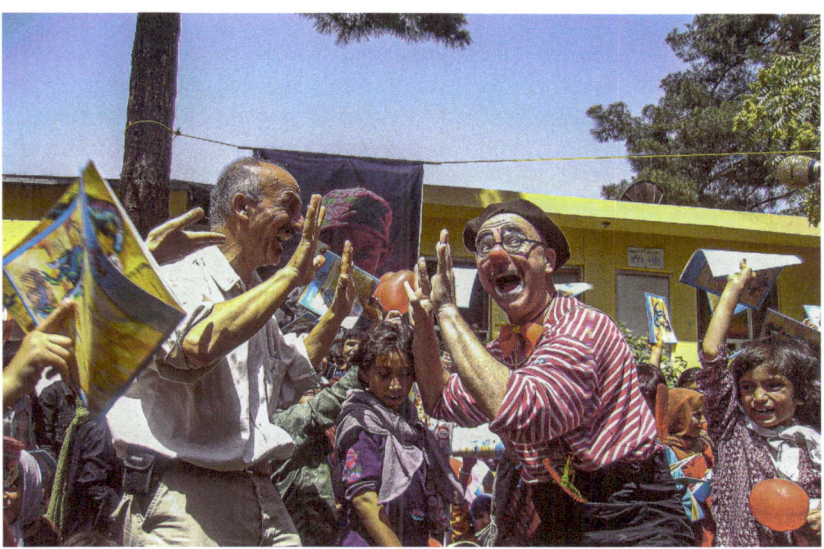

Reza Deghati at a party with the students.

In a way, it was like using the "double L" cut outs that could be placed over a print to demonstrate different compositional approaches. Several of the students had prior art training and immediately related to what I was attempting to convey to them about composition and center of interest.

A BBC reporter, Alistair Leathead, came by to see the project at 5:00 p.m., and several of the students were able to continue working with their images beyond the normal closing time. They had discovered "Filters" in Photoshop and were laughing as they prepared bizarre treatments of the photos they had taken earlier in the day, pushing the saturation and contrast to extreme limits, adding blur and noise, and using other techniques. It was learning by exploration, and students who weren't afraid to make a mistake could really soar.

The assignment for the next day was to photograph where they lived, and to include their parents and siblings. I had wanted to see how they lived, and it was going to be impossible in the time available to make personal trips to the students' homes, even if that had been permitted. There had already been some parental concern expressed about the young people being in school—much less taking pictures—as Islam traditionally forbids the depiction of the human form in their art.

By 6:00 p.m. I was back in my hotel room with the cold water of the shower running over me. Plans for the evening were not a quick trip to bed but an invitation to J. B.'s apartment for dinner. Fortunately, the shower refreshed me. Just after I got dressed, Sarah called from the lobby, ready to take me to the embassy employee's secured living area for the dinner. It was a nice evening, and we drove to an area of Kabul known as "the Green Zone." We entered the compound where all the State Department employees who were US citizens lived under tight security. "Nationals," or locals hired by the department, lived in the city. Contract security guards, decked out with loaded weapons, checked and secured our passports, and assigned us to an escort officer, Tim Moore, who also was to dine with us that evening. We were each issued a visitor's badge to hang around our necks.

J. B. had a small but very nice balcony off of her tiny dining/living room/kitchen, and we sat there talking about the Department of State mission in Afghanistan. Discussion ranged from the local urban culture compared to the tribal areas to the problem with drugs and the economy. The party consisted of Tim, who had just arrived on station from Lithuania; a woman from Jalablad who worked for State and was in town for a conference; Sarah's husband, Mark; J. B.; and me as "guest of honor." I had an Australian beer, the first alcohol since leaving Abilene. It was cold and really good.

I think one of the really fine opportunities traditionally afforded our State Department employees is to immerse themselves in many differ-

ent cultures during the course of their employment. Unfortunately, but understandably in Kabul, J. B. was essentially confined to quarters with little opportunity outside the requirements of official business to move about the city, much less the country. The risk of being targeted by hostile groups was far too great. Nevertheless, J. B. was able to experience much of the local culture even with these restrictions, and it was a pleasure for her to learn more, even secondhand. I was ready for bed when we walked down the guarded street to meet F. H. and the van.

 I slept soundly.

CHAPTER SEVEN

The Fifth Day— Photographing Family

The next morning F. H. was about fifteen minutes late. Deeply apologetic, he explained that traffic had clotted all the roads into a slow-moving viscous stream and all he could do was "go with the flow"—words that would prove provident almost immediately. Although the class assignment had been to photograph home and family, not one of them had done so. Perhaps their families had forbidden it, but every student uploaded photographs of other subject matter. Disappointed as I was, I continued with my plan to interview each of them on the topic of their original assignment.

While the students downloaded their files from the previous day's shooting—on everything from street people to office buildings—I searched for a quiet corner that could be used for the interviews. F. H. agreed to translate my questions and the answers so that there would be less chance for misunderstanding. We finally settled on the big gallery room and brought in three chairs to pull to the small table in one corner.

The system worked pretty well. My little Sony digital recorder picked up the voices pretty well, and F. H.'s voice was strong and clear. I knew that unfamiliarity with the names would be a problem for Kimberly Edwards, my assistant in Abilene, when she began to transcribe the files, but we would just have to do the best we could.

I developed a short format for the questions beginning with the date, time, and respondent's name. Then I began asking general questions about each student's family: how many siblings, what the parents did for a living, where they lived, etc. The commonalities were striking and often painful.

They all came from large families and were all living with at least one parent. Often that parent was not able to work. Many were disabled from gunshot wounds or illness. One student's father was disabled by mental illness. Income from other family members was all that kept them afloat.

Most of my students had been working at one job or another before they had been "rescued" by Aschiana and were progressing through the

system. When asked about their vocational plans, most wanted to be doctors or other higher-income professionals. One dreamed of being a pilot for an airline, and of course, all wanted photography to be a part of their lives. Public service—helping others—seemed important to each of them.

Since one of my hoped-for personal outcomes from the trip was to learn more about what was actually happening in Afghanistan, I always threw in a couple of questions about the war and its impact on their lives. Their answers were reasonably uniform. Life was more settled under the Taliban. That, they liked. There was less uncertainty. Life was stable. That was the end of the plusses. The older students with knowledge of the outside world found the Taliban's harsh religious stance difficult to understand. However, most of the students were very young during the times of the Taliban, so they remembered little of what it was really like.

My oldest student, Mohammed, now attending Kabul University, grew up in a village near the Iranian border. During the war with Russia, his family moved to Iran and stayed there until it was over. They moved back to their old village where the brothers all had small businesses and the father was a farmer. (I didn't ask what he raised . . . maybe poppies.) Mohammed announced after graduating from public school there that he wanted to go to college, but his father saw no point in it and wanted him to find work instead. He left for Kabul anyway and supported himself on the street while attending the university.

Mohammed says that his family has now accepted his decision and that he receives a small amount of money from them for assistance. When he returns to the village to visit, he has to grow a full beard because the Taliban have reoccupied the territory. "If I don't do it," he said, "they will kill me."

My final question was to ask the students to tell me what they would like to say to America.

All were pleased that I had come a long way to work with them and wanted to express their appreciation for the many donors that had made possible the acquisition of the digital cameras for Aschiana. Most of them were aware of and grateful for the aid and support America had provided their country and wanted to say thank you on behalf of their country. Finally, as they got up to leave, their eyes met mine and they said, "don't leave us." They dreaded the instability that they knew would follow the departure of the stabilizing international force until their government grew strong enough to protect the people.

It was a sobering thought to know that one of these days we WILL be leaving Afghanistan and that the Taliban with their extreme religious views will be waiting in the wings. Realistically, the older generation will never change. The young people in my class and thousands like them are the future of Afghanistan. Somehow, they must acquire the understand-

ing that will propel their country into the twenty-first century.

I was thinking about these issues as I undressed for bed. Just a few short minutes later, my thoughts turned to pain relief. It had been a hot, tiring, but focused day. I showered and sat down a bit too hard on the firm mattress and immediately I felt a shooting pain in my back, hip, and leg. My old tennis injury had come back with a vengeance.

It didn't take a physical exam to tell me something was seriously wrong. I tried every position to relieve the burning, throbbing leg and back. Nothing worked, although standing seemed to be the best position, so I was up and down the rest of the night and taking as much Advil as I thought my stomach could stand. It seemed the morning and the chance to get some stronger medicine would never come.

While I was tossing and turning, another thought burst into my consciousness. How was I going to get home on Sunday? It was obvious to me that it would be extremely painful to squeeze my 6'3" frame into tiny coach seats for over twenty-three hours of flying.

CHAPTER EIGHT

The Hospital and Farewell to Kabul

The next day, Friday, F. H. arrived with Sarah and took me to the local hospital, where I secured a cloth back brace and some stronger pain medication. Things improved, and they drove me back to the hotel where I tried to get some sleep. This was the day that the students had their official graduation. Unfortunately, they had a graduation event in my absence.

When Saturday rolled around I was still too uncomfortable to walk around. This was the day I had planned to drive about the city with F. H. and make some images of my own. What a missed opportunity! I regretted that I did not have a chance to see the students again but received a beautiful card with all their signatures wishing me a speedy recovery and thanking me for the course. I later heard that as a result of this workshop, Hashmat, one of the older participants, had agreed to continue teaching the others how to use Photoshop and improve their computer skills.

I rested the remainder of the day, and on Sunday I was packed and ready to depart.

I anxiously waited for F. H. and Sarah to pick me up and take me to the airport for my trip home via Dubai.

We arrived at the airport a couple of hours before flight time and parked in the designated lot. No curbside check-in at the Kabul International Airport! Fortunately, there were porters available to carry luggage, and off we went with me hobbling behind the Afghan track star pushing my cart and hoping the prospect of my tip would offset the possibility of his disappearing into the distance. The track star was waiting as I arrived at security and eagerly accepted my $5.00 tip, put my bag on the conveyor belt, and hurried off for fresh customers

I said goodbye to my friends, Sarah Johnston and F. H., who had been so supportive of my work with the students and had assisted me the last day with my trip to the local hospital. They were terrific. I turned from the last-minute hugs and entered the magic arch knowing it wouldn't buzz because I had unloaded every conceivable metallic source of concern.

I was patted down anyway. Shoes were not removed as in the US, but the checked bags and carry-on were opened and examined thoroughly. At

Entrance to Kabul Hospital.

the last inspection, I opened my shaving kit at the inspector's request and he promptly confiscated my backpacking shaving mirror. It was a curious but minor loss. I passed on to the waiting room where I went through an identical examination and passport check, finally ending up in a waiting room with a couple of dozen Afghans. The room was a contrast between the modern and the ancient. The plain white plastered walls were devoid of decoration of any kind. No pictures, no instructions, no advertisements, and the single sign was lettered "Internet" in English with an arrow pointing down the hall. I thought it amazingly anachronistic. Like the city, it was a curious mix of almost modern and absolutely ancient.

Looking around, I found a seat opposite two Afghan men whose long black beards stood in stark contrast to their white garments. In fact, the entire room was filled with men wearing white or a light pastel dress-like shirt that reached below the knees with a pair of white leggings underneath that came to the tops of the shoes. Most had hajj caps on their heads and black or tan vests that were unbuttoned. The only other person wearing a "gimme cap" in the entire room was an ex-marine contractor on his way for R&R. The Afghan men all struck identical postures: one leg folded under the other, which was extended to the floor or hiked to the bench.

The atmosphere, thick with smoke, was hot and humid. There was a long line at the counter where water could be purchased. The floor was

dirty, but the seats were good with lumbar support for my back, which finally stopped hurting. A few women with their children began to filter in. They were uniformly dressed in black with the veil covering their mouths and noses. All that showed were the heavily decorated eyes. They held their heads cast down and looked directly at no one. A few Anglos began to enter and sat together in a group. The western women quickly insulated themselves from other travelers with ear buds and iPods. There was a buzz of conversation in the room. As I observed the men across from me, I was startled to see a red stain on both their hands. I knew it was from Friday's religious celebration, but it looked as if they had just butchered a sheep. Perhaps the color fooled the flies also because they were buzzing about everywhere.

CHAPTER NINE

Dubai and Heading Home

The flight to Sharja went quickly. Perhaps it was the medication, because I slept most of the way, which was unusual. We arrived in mid-afternoon and after more passport checks and X-rays, I quickly caught a cab to Dubai, which was about thirty minutes away. The hotel was beautiful—new Twin Towers of Dubai, a swanky four-star hotel that was part of the modern Arab world. I was glad for a day layover in Dubai in case the three-hour trip was too much for my miserable back.

I checked in quickly and continued my nap till time for dinner. I treated myself to a very fine martini in the fifty-first floor bar and planned the next day's activities as the sun sank toward the horizon with the ubiquitous sandy tan sky.

The bar was modern and efficient and staffed by a tall, athletic black man with a shaved head and a commanding presence. Very polished. The waitress who came to my table was young and attractive. She had signed on with the hotel for a two-year contract and came from Uzbekistan. It was her chance to see the world. The only flaw was the improbable use of photographs of the hotel on the walls that were hung haphazardly over other wall decorations and the dirty windows that were the result of yesterday's sandstorm.

The bar began to fill up with young attractive men and women, well dressed with expensive clothes worn casually. The men were tie-less and had their shirttails hanging out. The women had everything hanging out. Not too appropriate for a Muslim country. I thought of the enormous gulf that separated the tribal culture of Afghanistan from the anomaly of the modern Arab world of Dubai. It was bigger than the Gulf of Arabia that I had flown over that day, and I wondered if it would last as long.

After breakfast in the room the next morning, I dressed and began to explore the hotel. It was vast with convention rooms, spas, and exercise gyms—the works. I scheduled a massage for the afternoon, hoping it would be beneficial for my back. Alice would like a small present, I knew, so my first stop would be the famous gold souk (marketplace) that

Shopping mall in Jumeirah Emirate Towers, Dubai.

Gold Souk.

contained hundreds of shops. Most of the goods were similar: elaborate gold necklaces, earrings, rings, and bracelets, called bangles. All were made from 22-karat gold. Each store posted the price of gold by weight, and the items were sold based on weight.

The gold souk was famous. Alice and I had visited there twenty-five years before, and little had changed. I enjoyed walking down the interior aisles and looking in the windows. The place was a hive of activity. Many Europeans and Arabs from Saudi Arabia, other states of the U.A.E., and Asia came there to shop for gold and diamonds. Many of the diamond cutters from Brussels and other European centers had moved to Dubai, and it was now one of the main centers in the world for fine jewelry. I saw an unusual bracelet in a window that I thought Alice might like, so I went in and made the purchase. Unlike in Afghanistan, credit cards were accepted, and the business style was definitely western, with well-dressed sales clerks and computers for inventory management, information, and recording of sales transactions.

My flight to Zurich left from Sharja so I returned the next morning in time for a 1:50 a.m. departure. I was able to sleep for most of the seven-hour journey to Zurich, and after about a four-hour wait, I boarded American Airlines with business class seating for the eleven-hour flight to Dallas. It gave me ample time to meditate on the experiences of the week. I recognize that my contacts with Afghan and Dubai people were limited and the time of contact only a week, but certain impressions emerged.

Photographs by the
Afghan Students

Photographs by
Student #1

Portrait of the photographer.

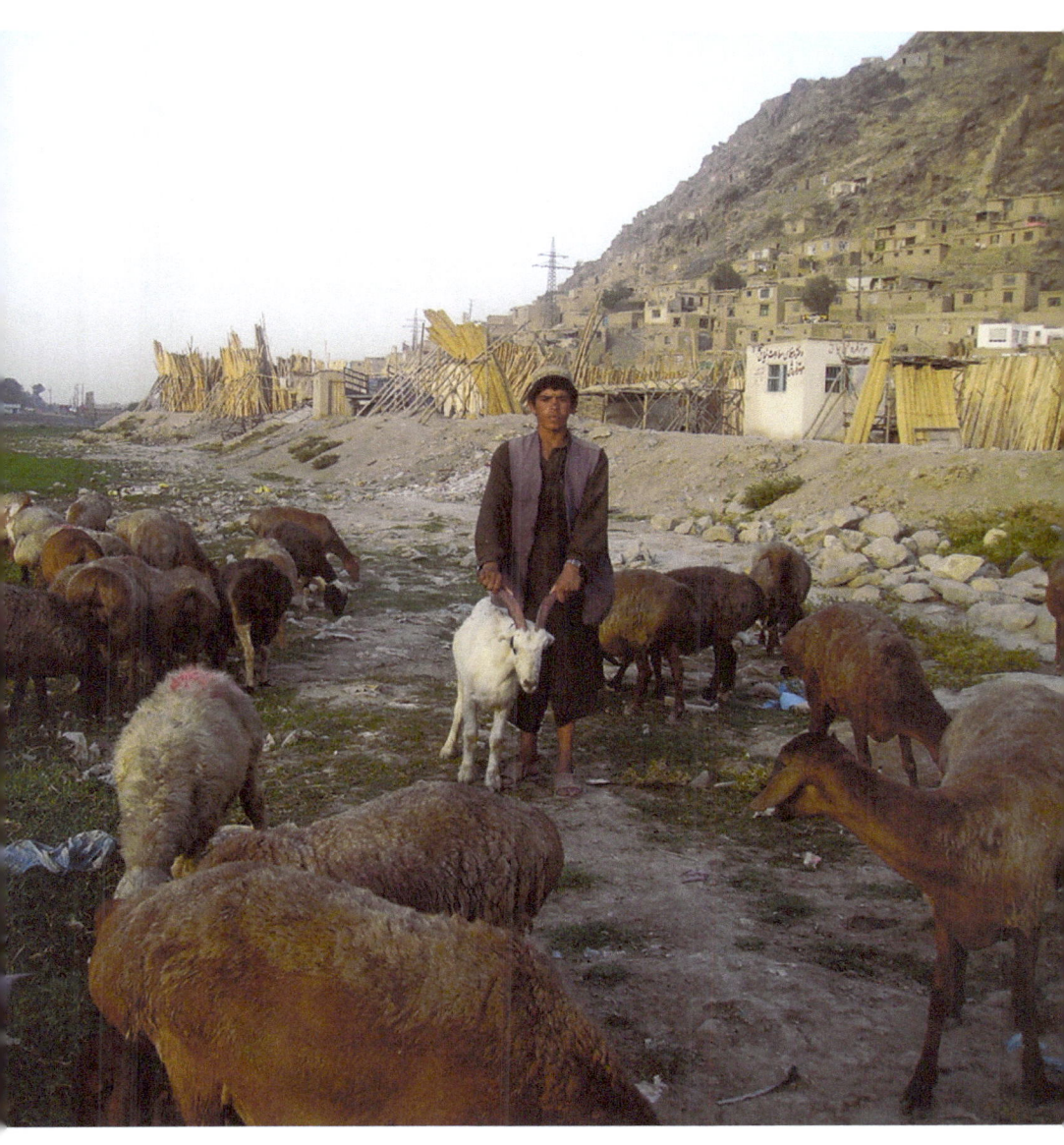

Photographs by the Afghan Students

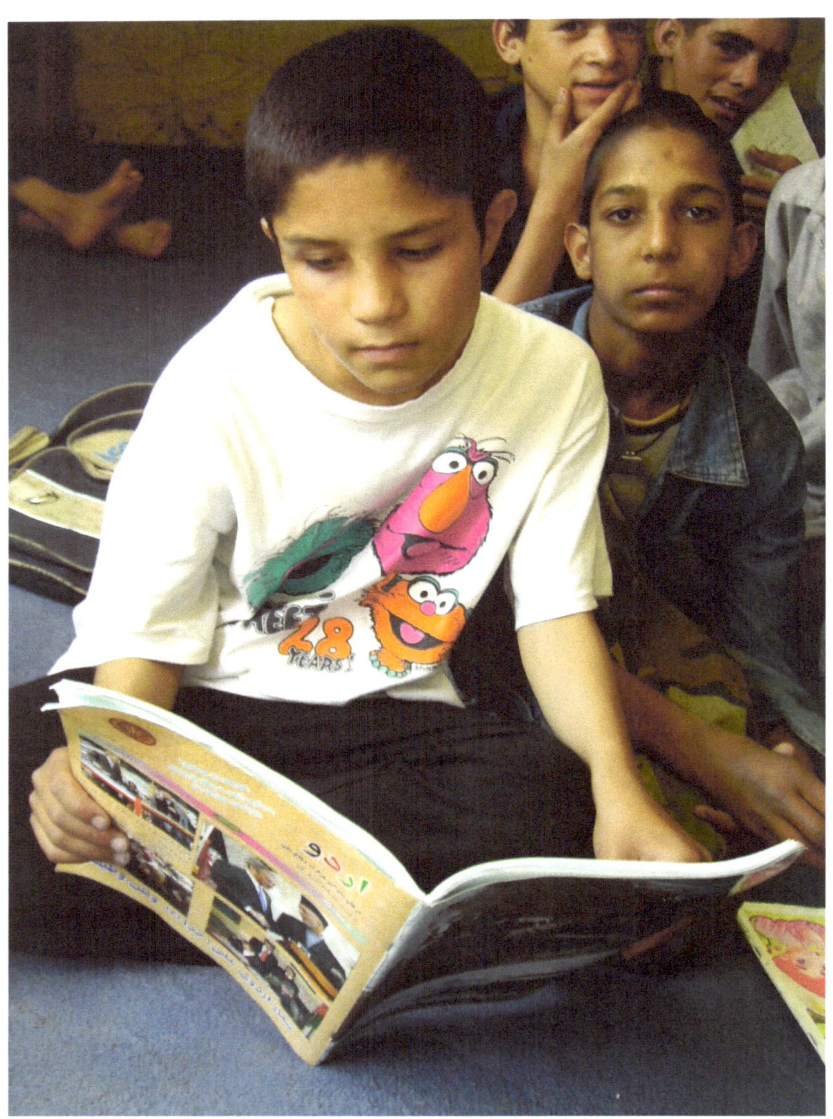

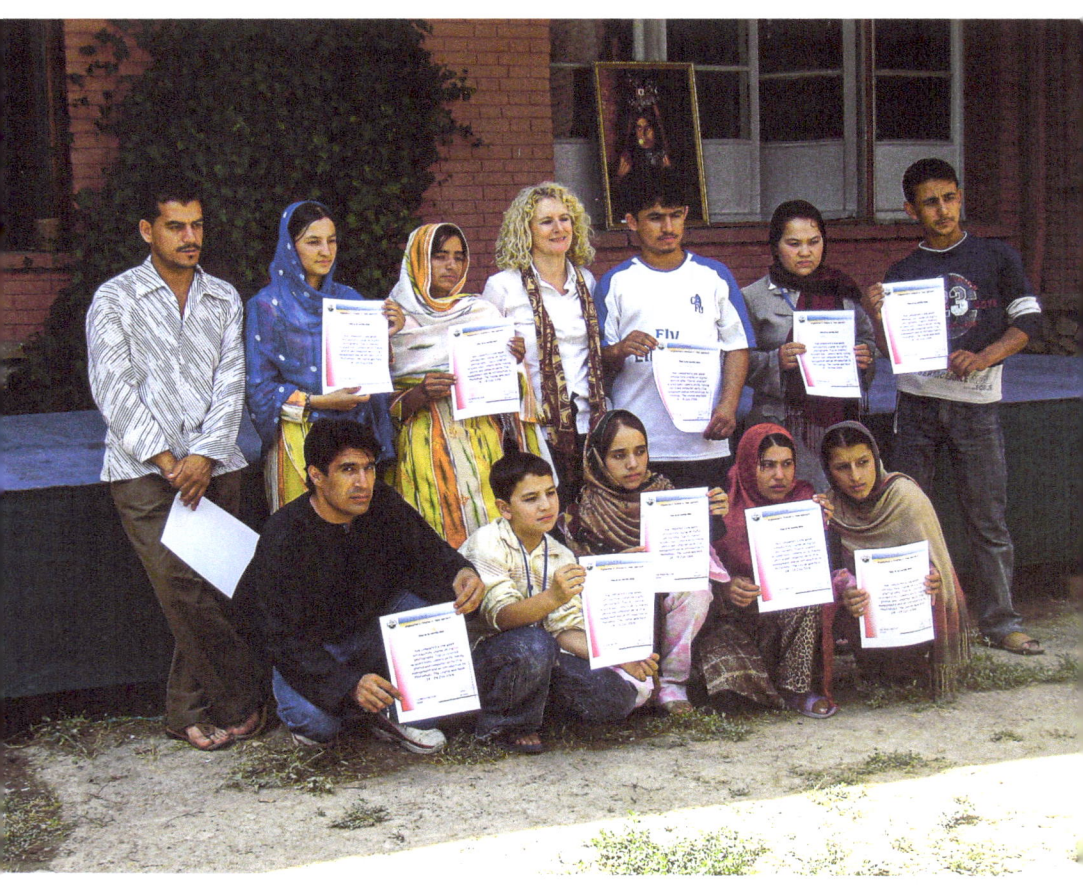

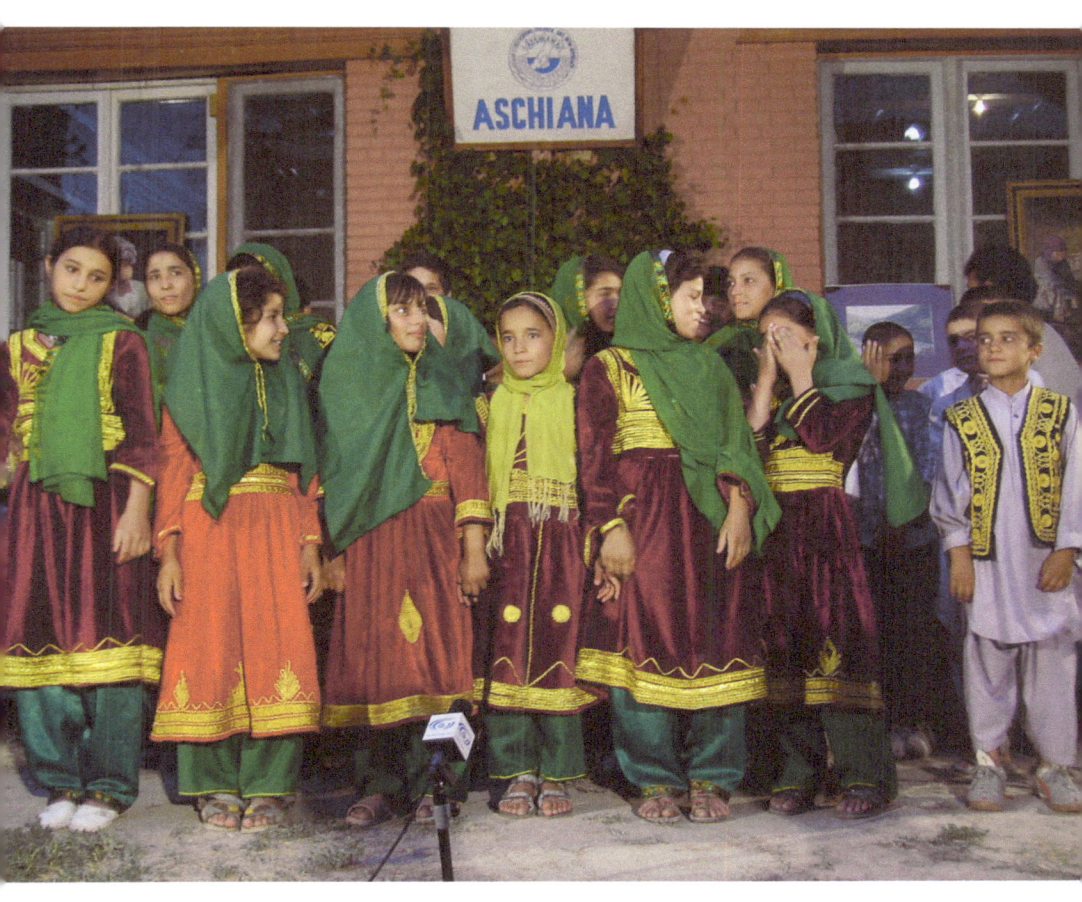

Photographs by
Student #2

Portrait of the photographer.

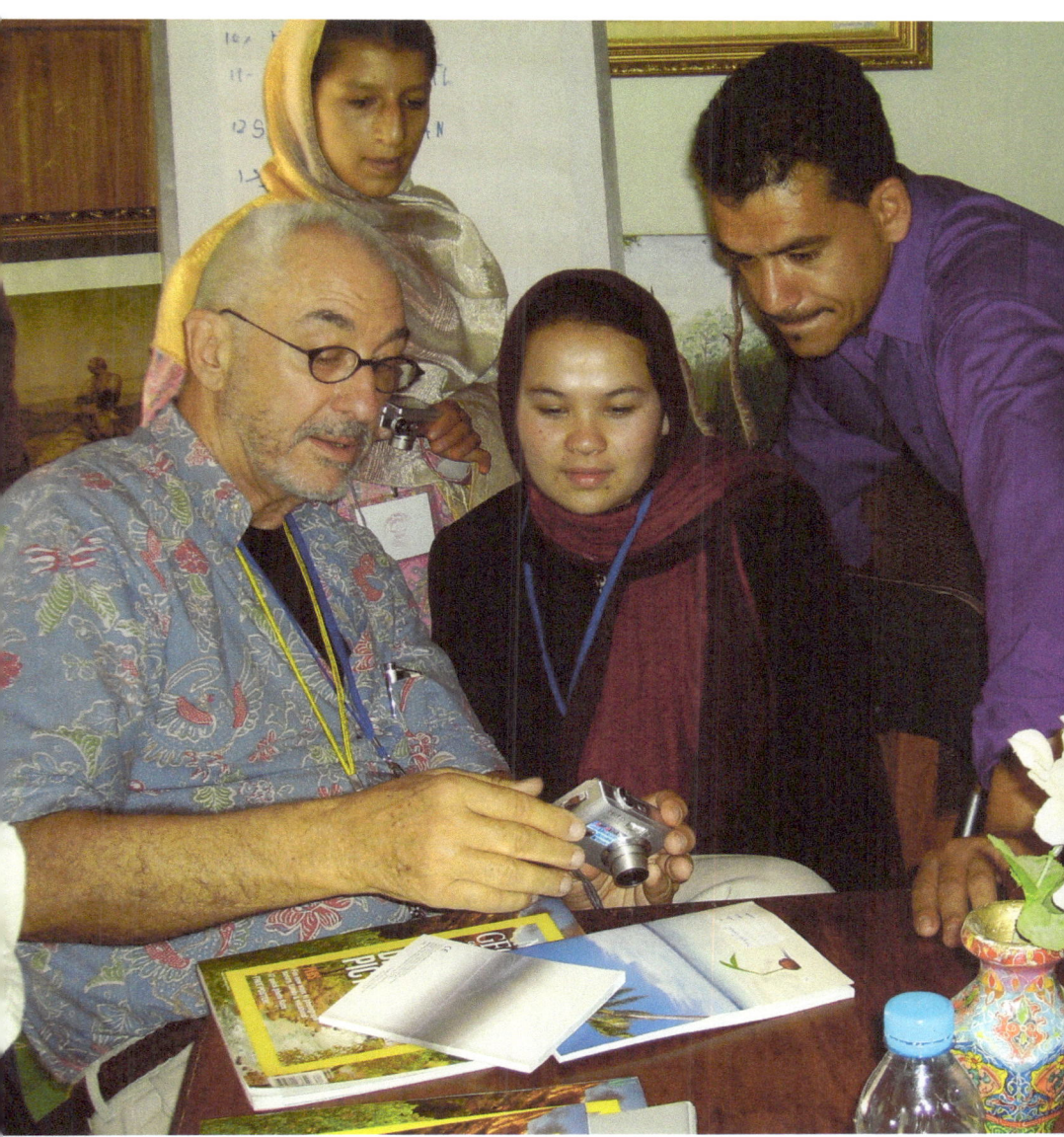

Photographs by the Afghan Students

Photographs by
Student #3

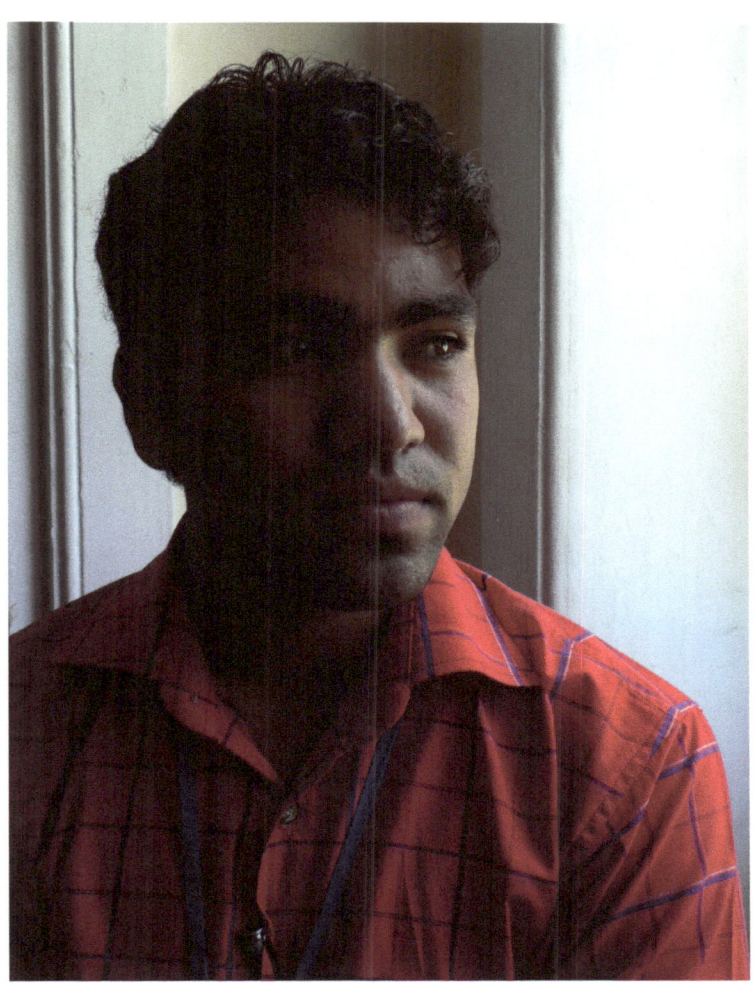

Portrait of the photographer.

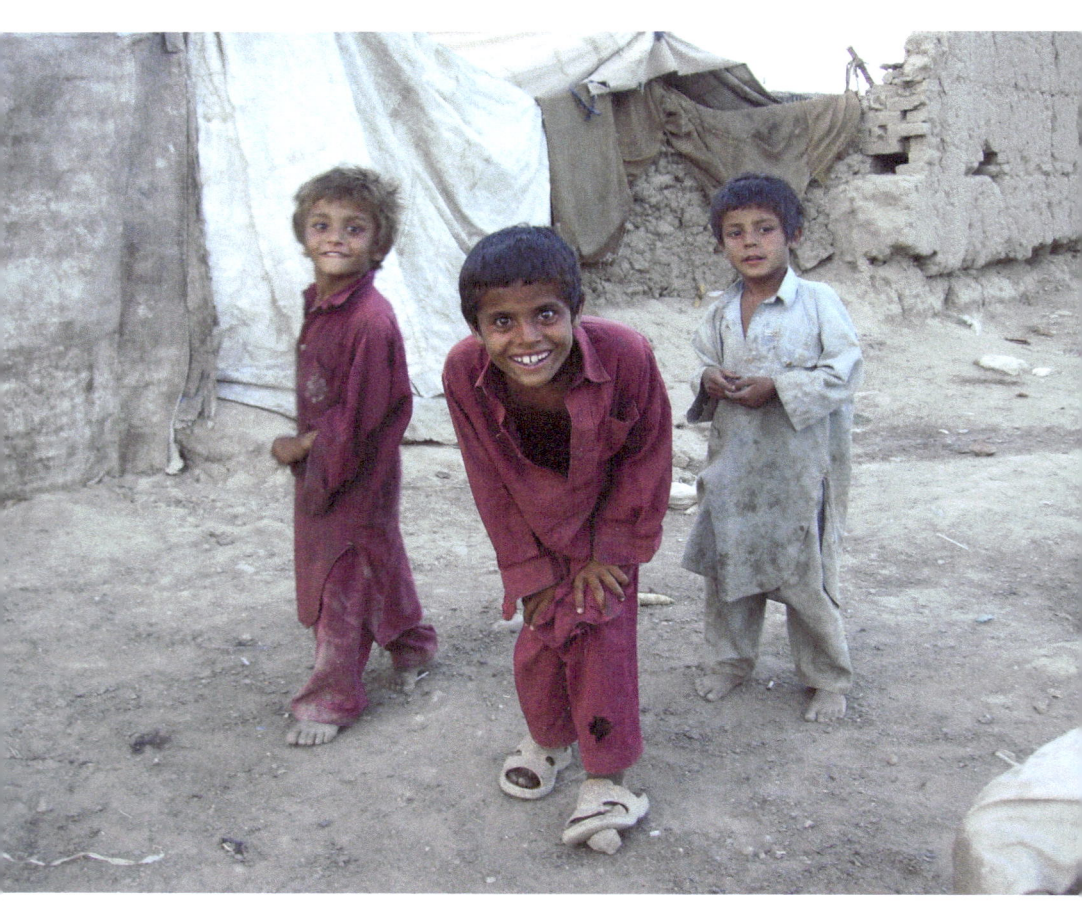

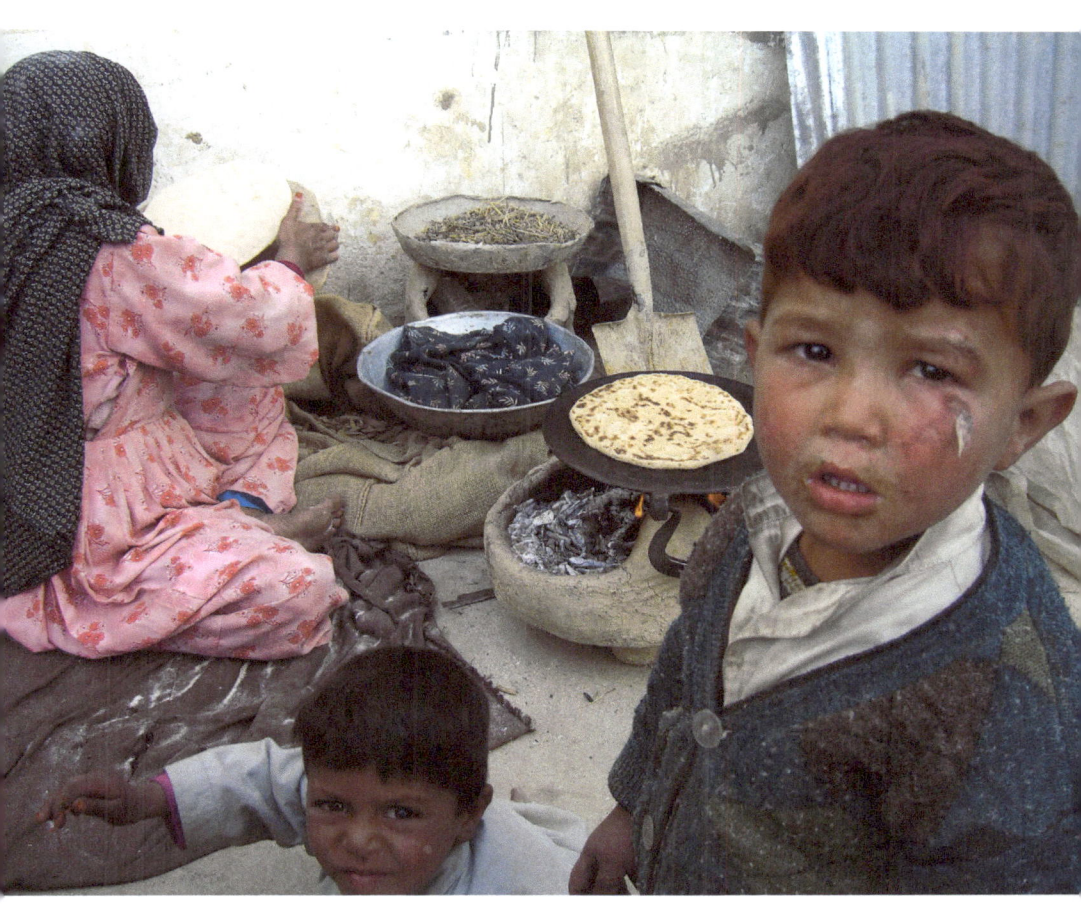

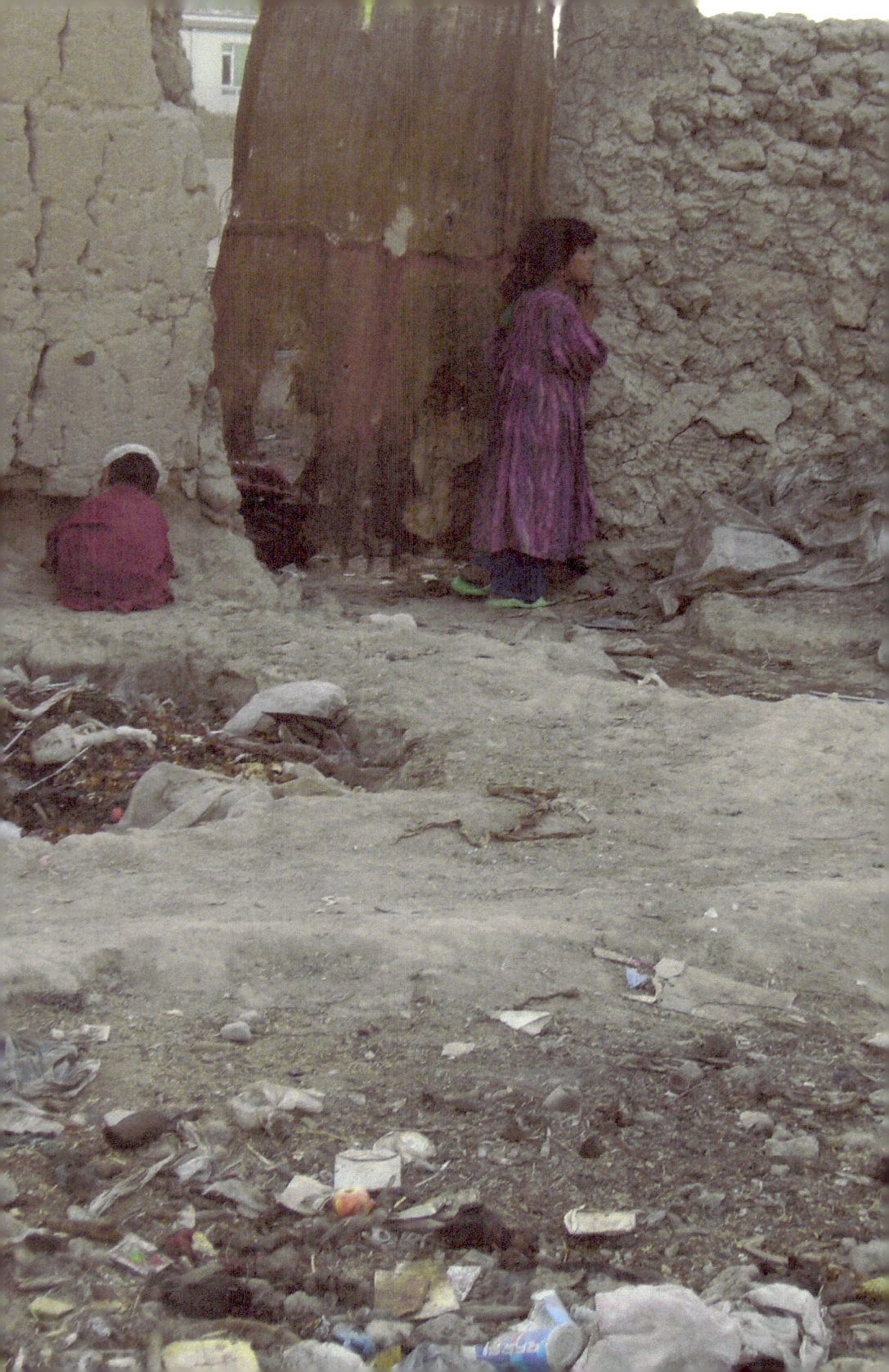

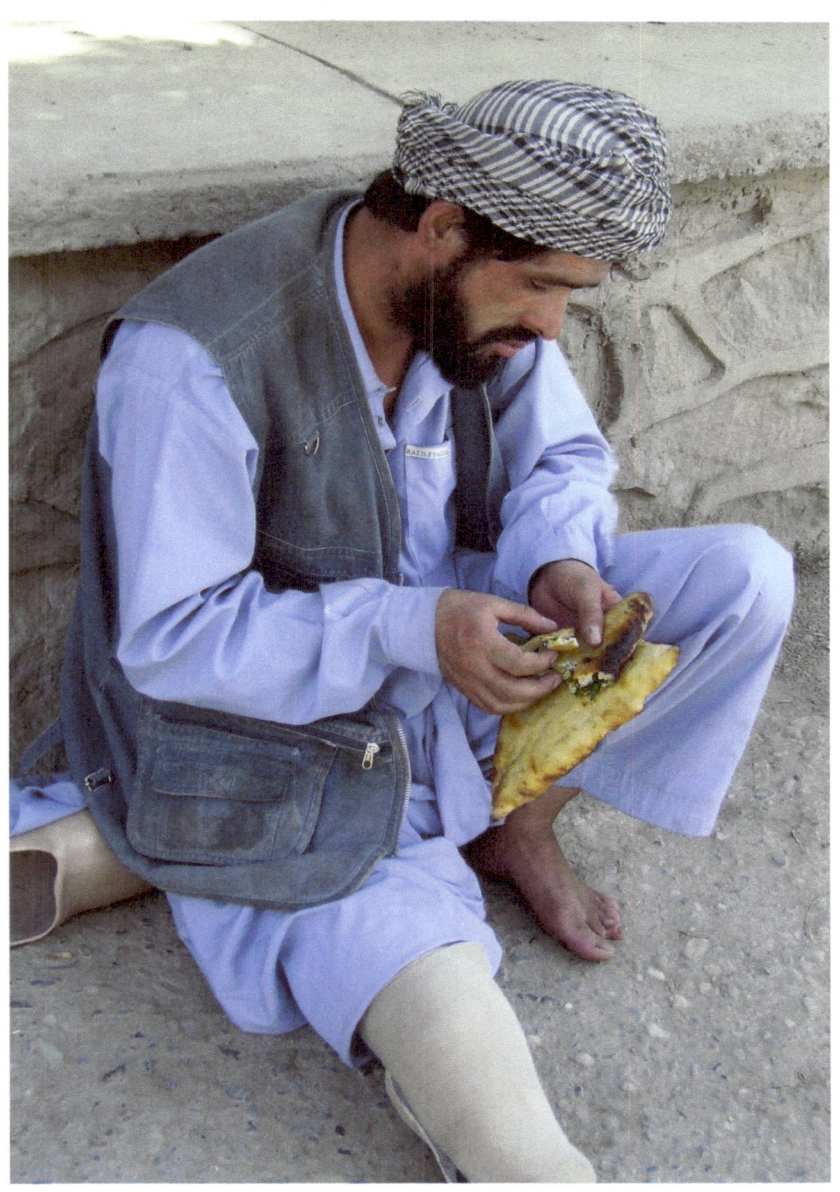

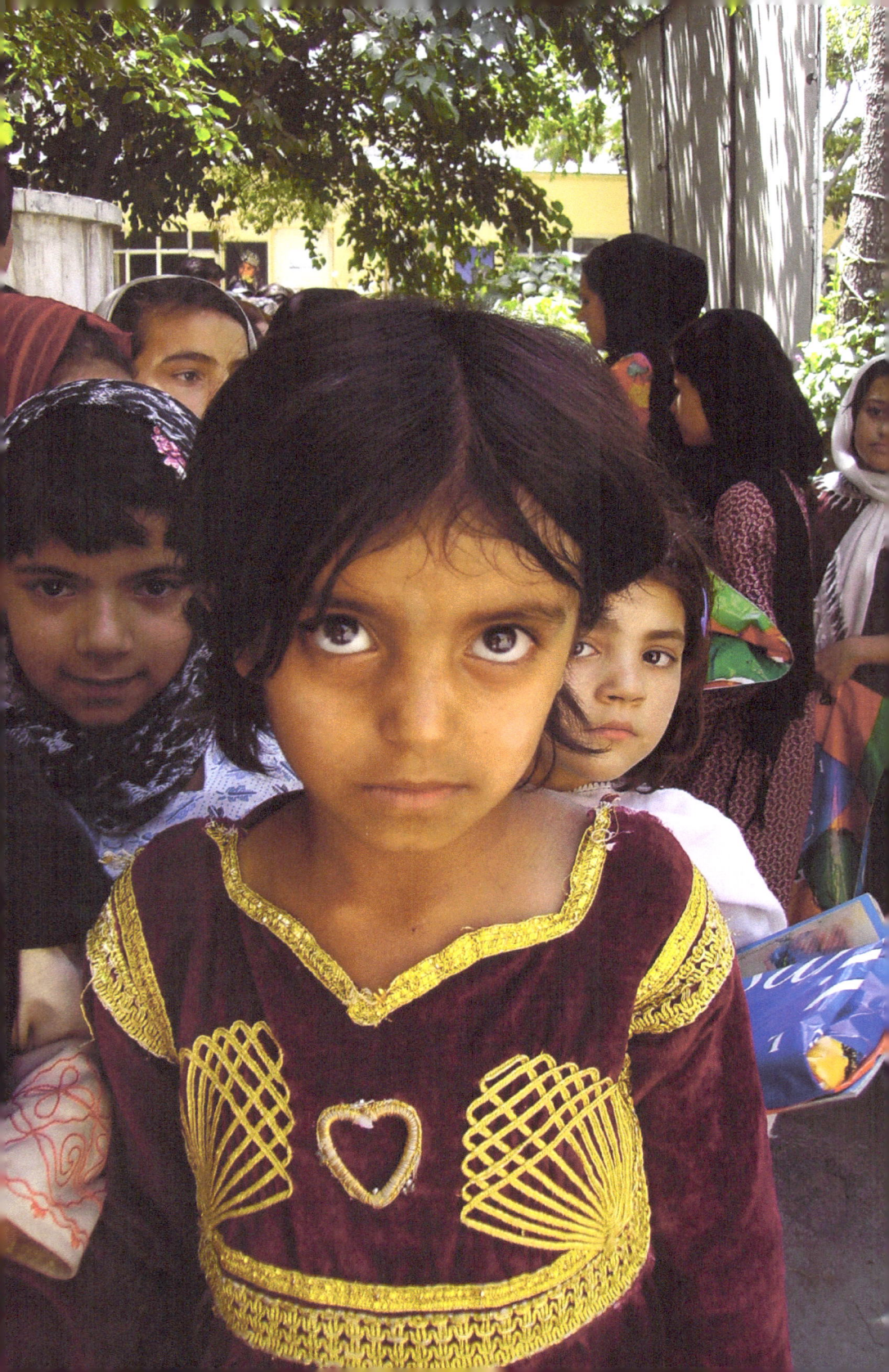

Photographs by
Student #4

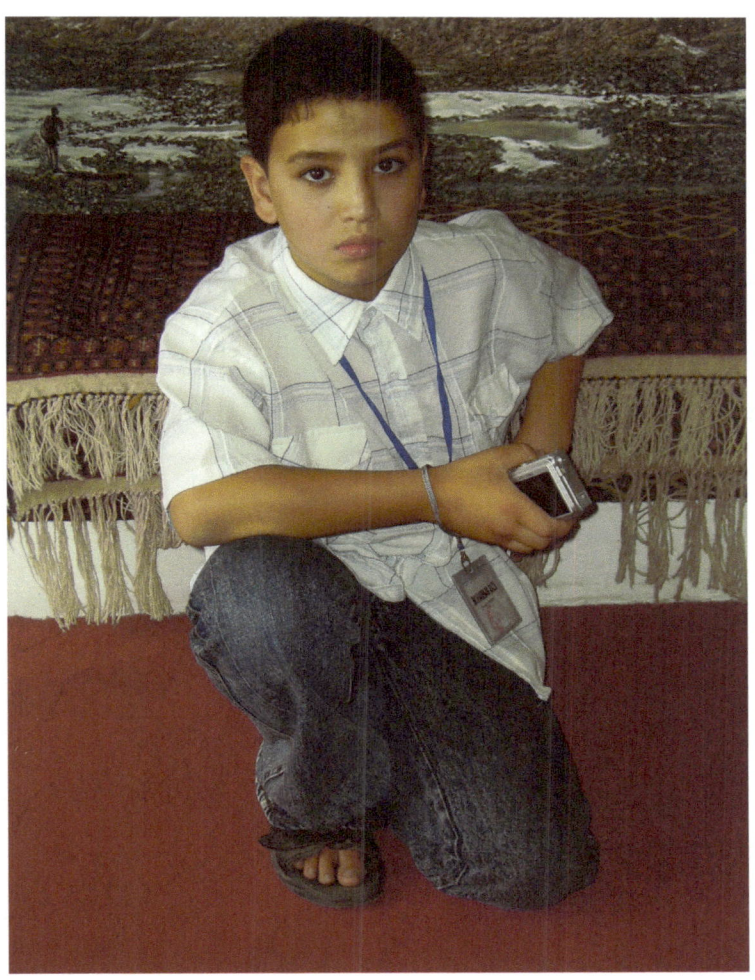

Portrait of the photographer.

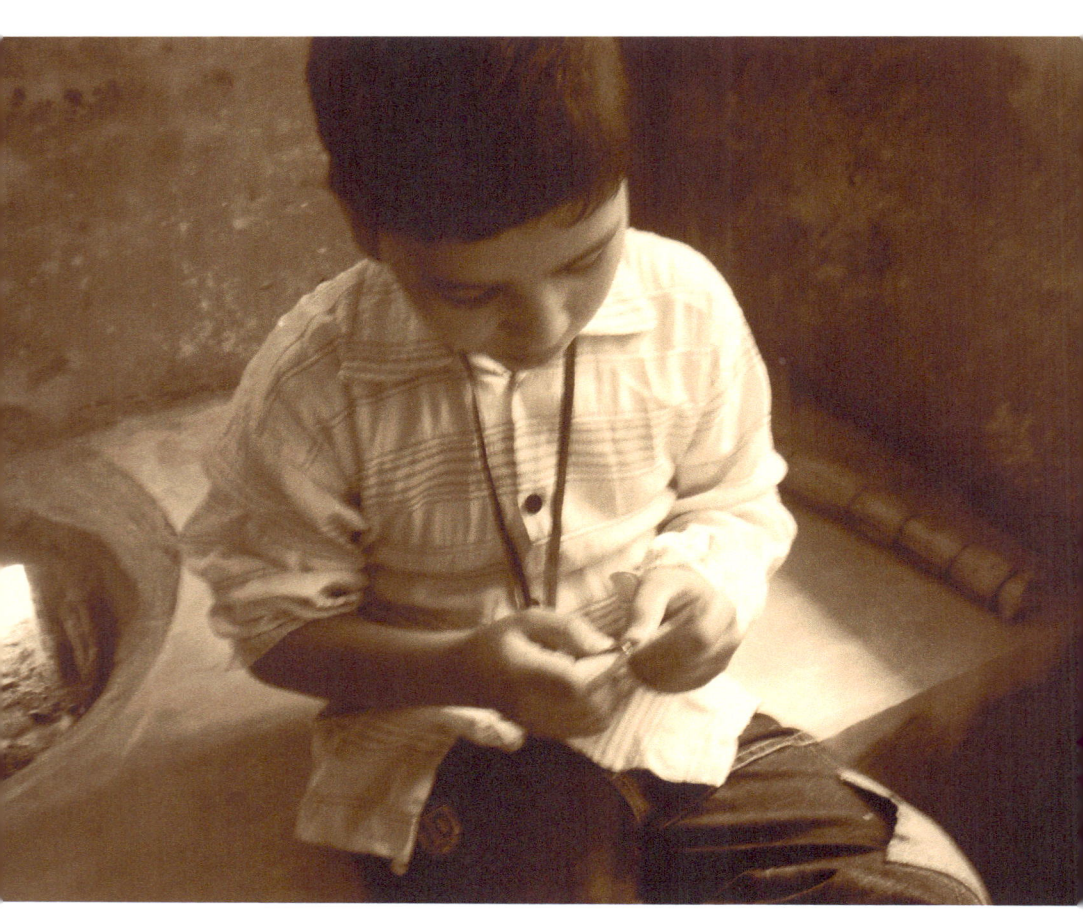

Photographs by
Student #5

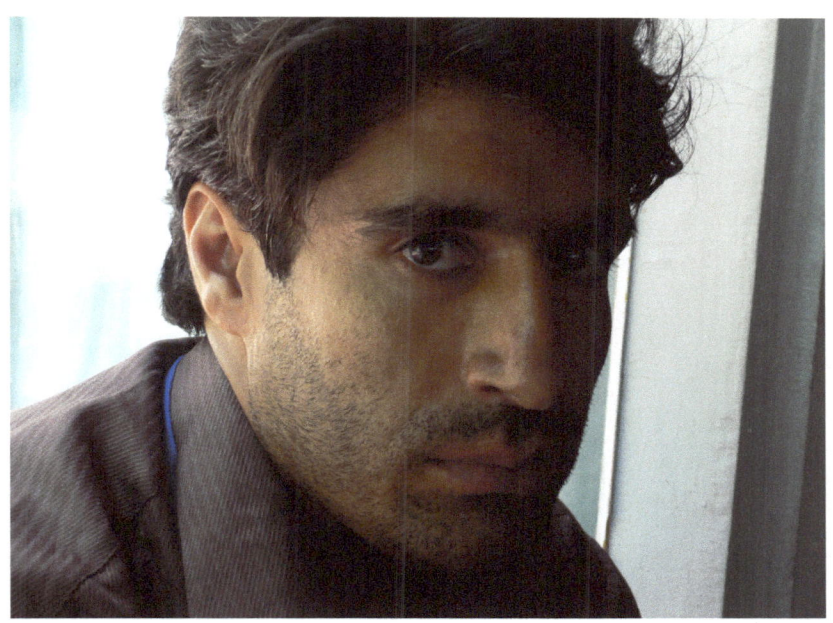

Portrait of the photographer.

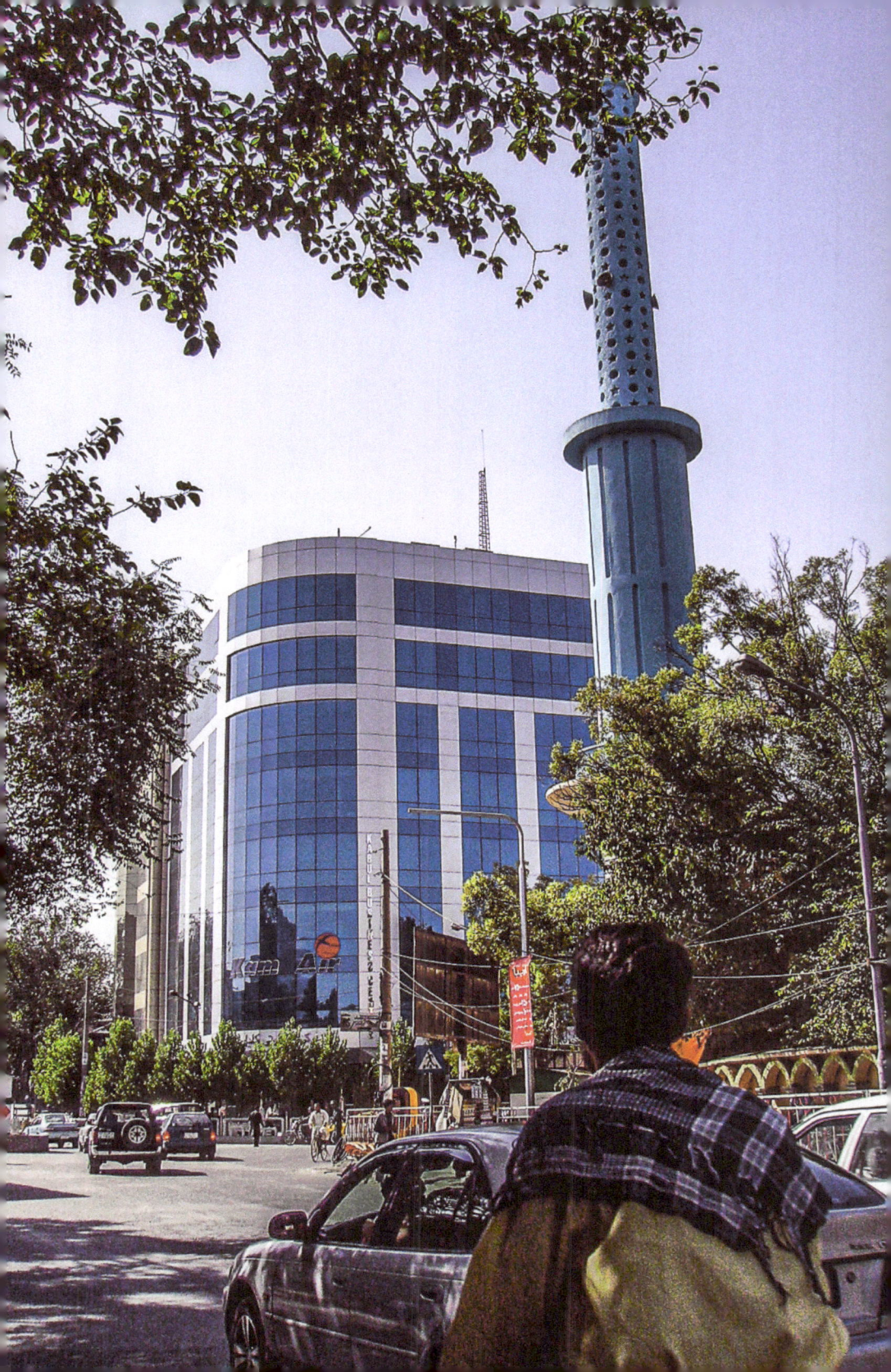

Photographs by
Student #6

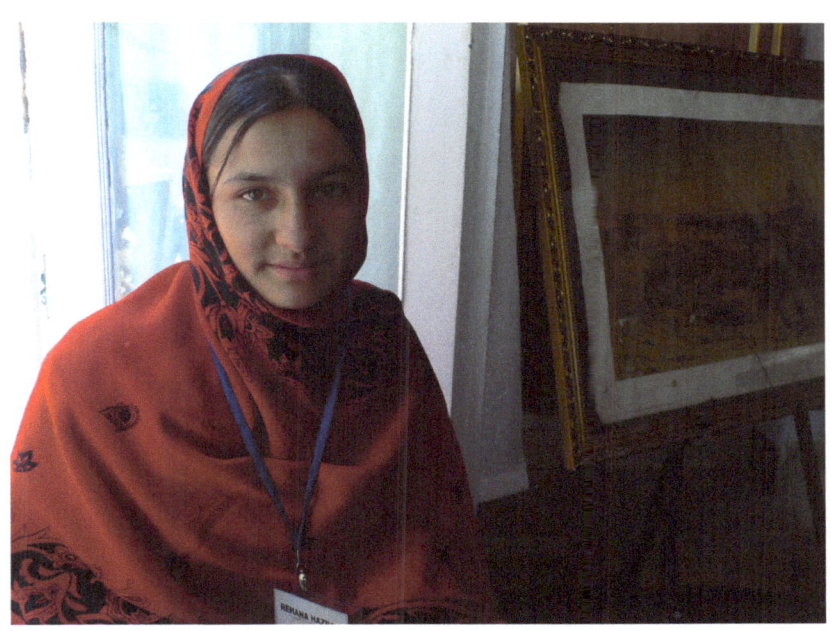
Portrait of the photographer.

Photographs by
Student #7

Portrait of the photographer.

Photographs by
Student #8

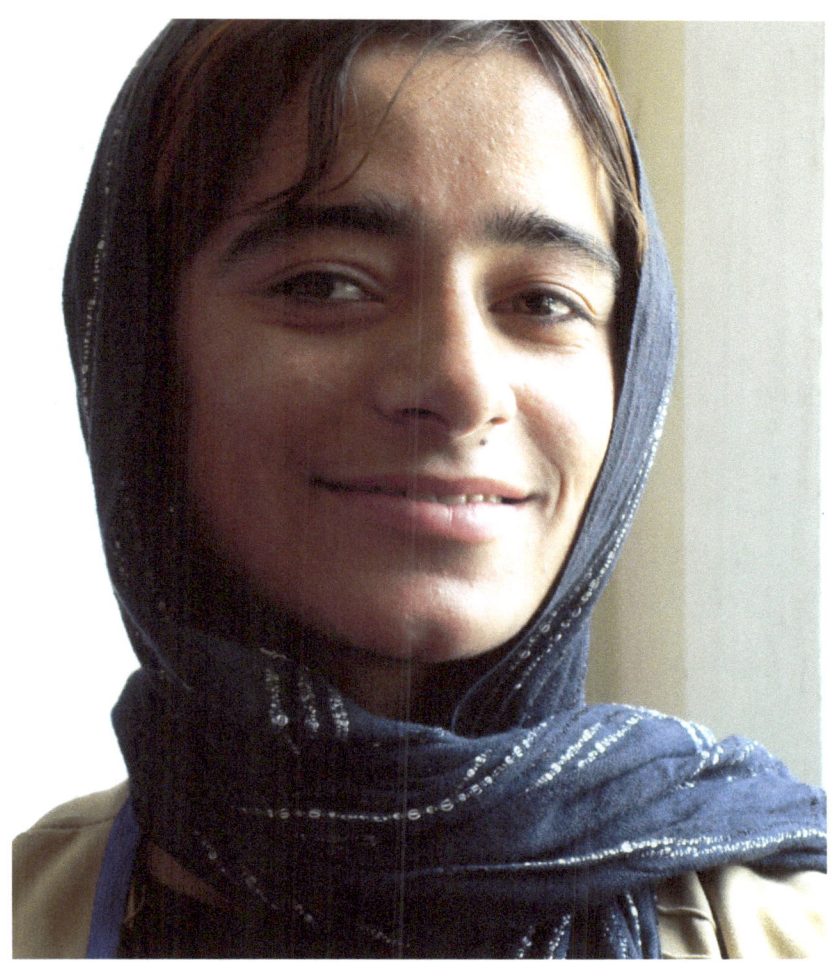
Portrait of the photographer.

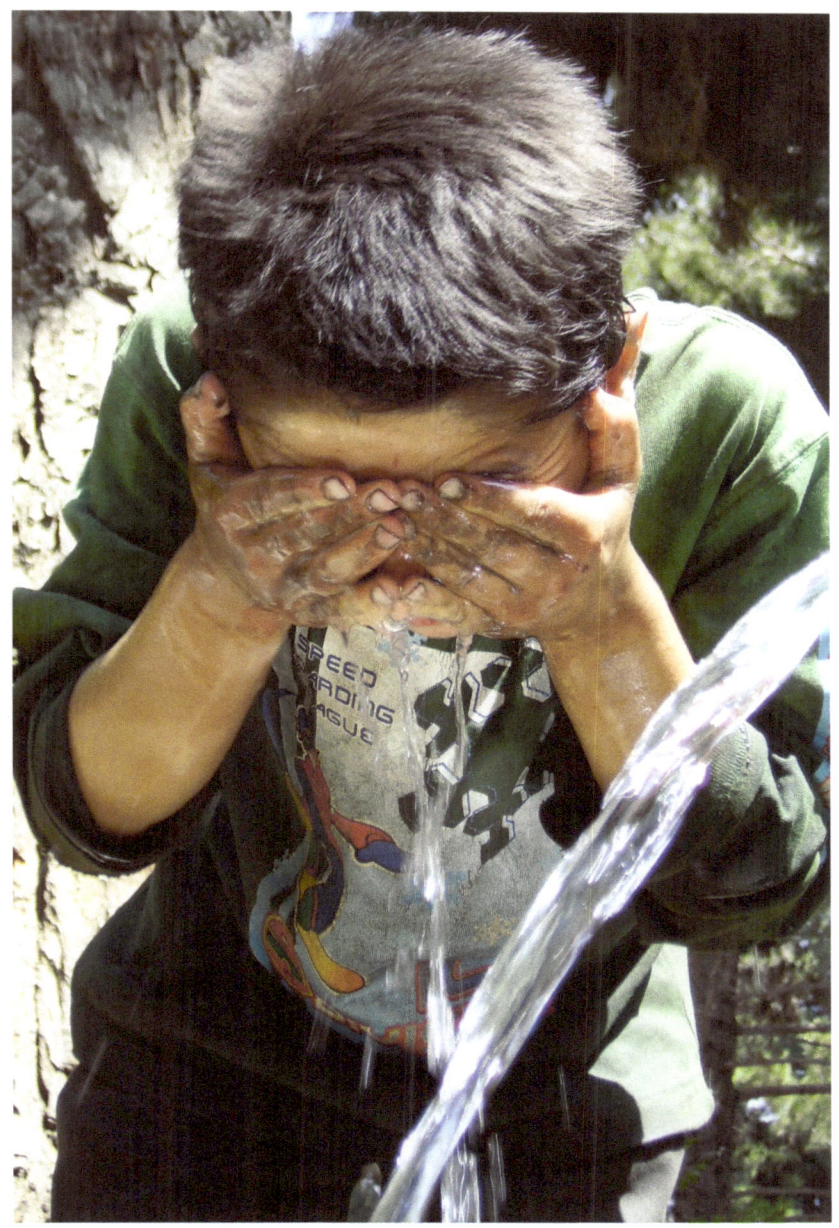

Photographs by
Student #9

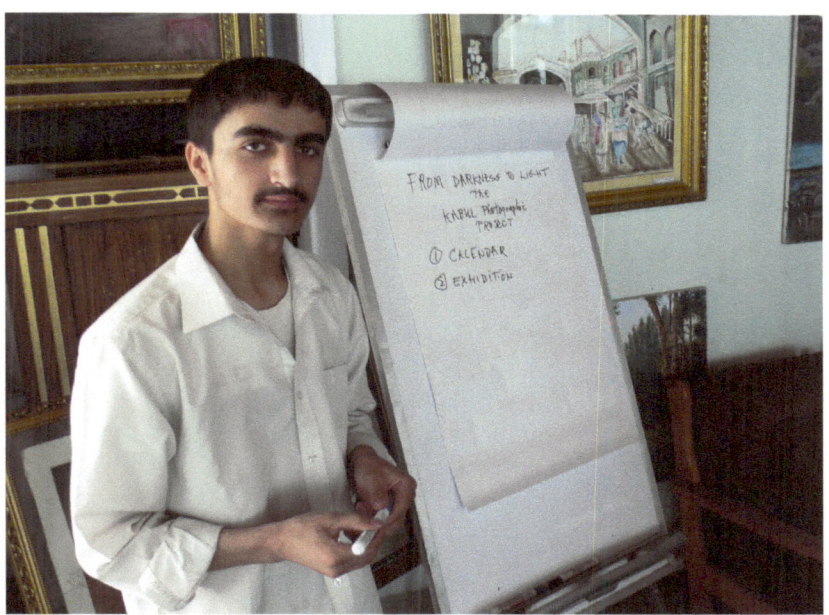

Portrait of the photographer.

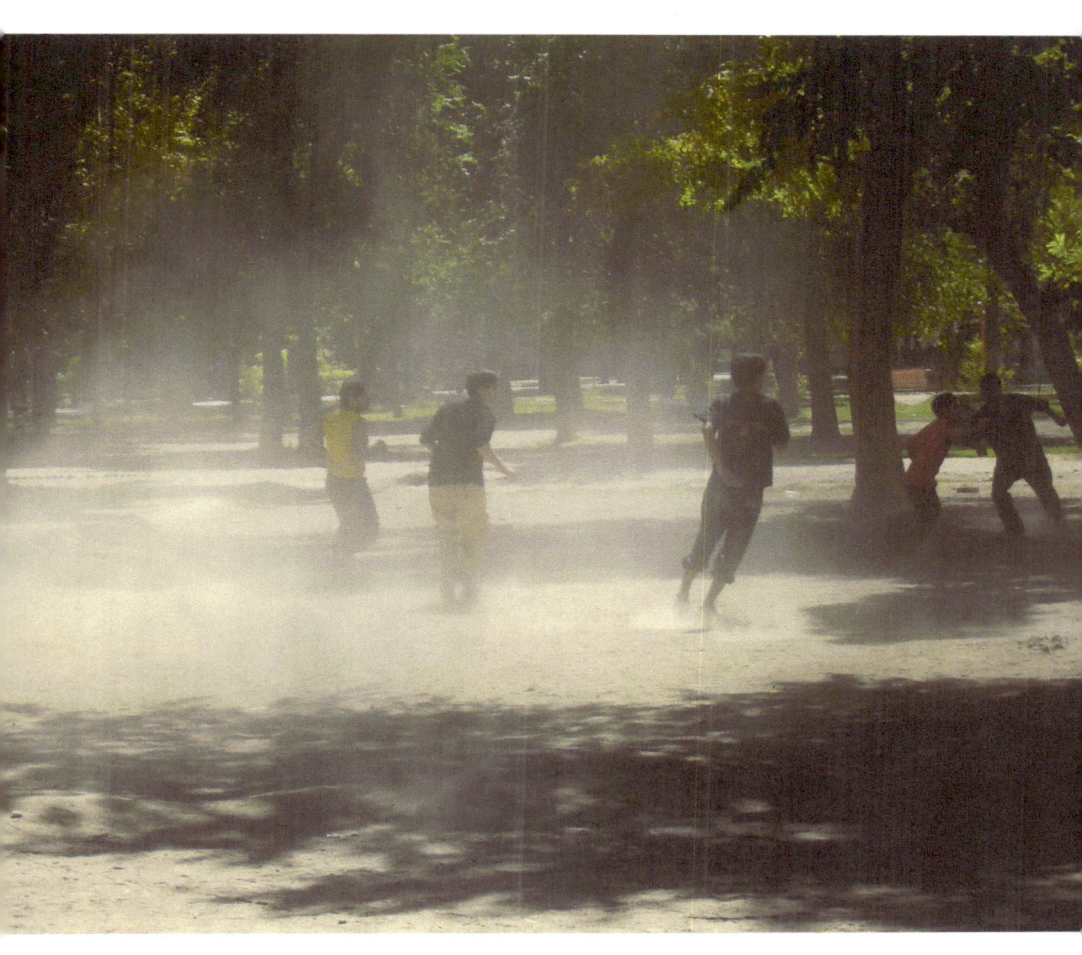

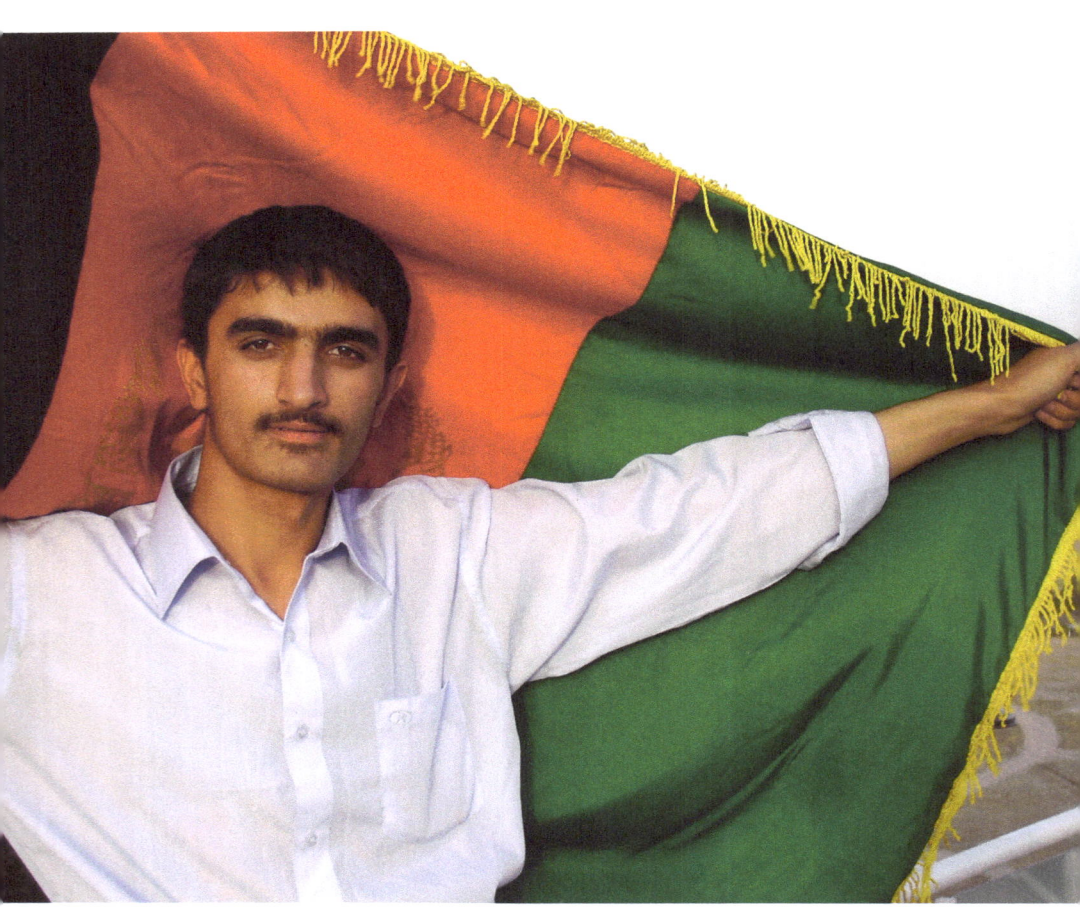

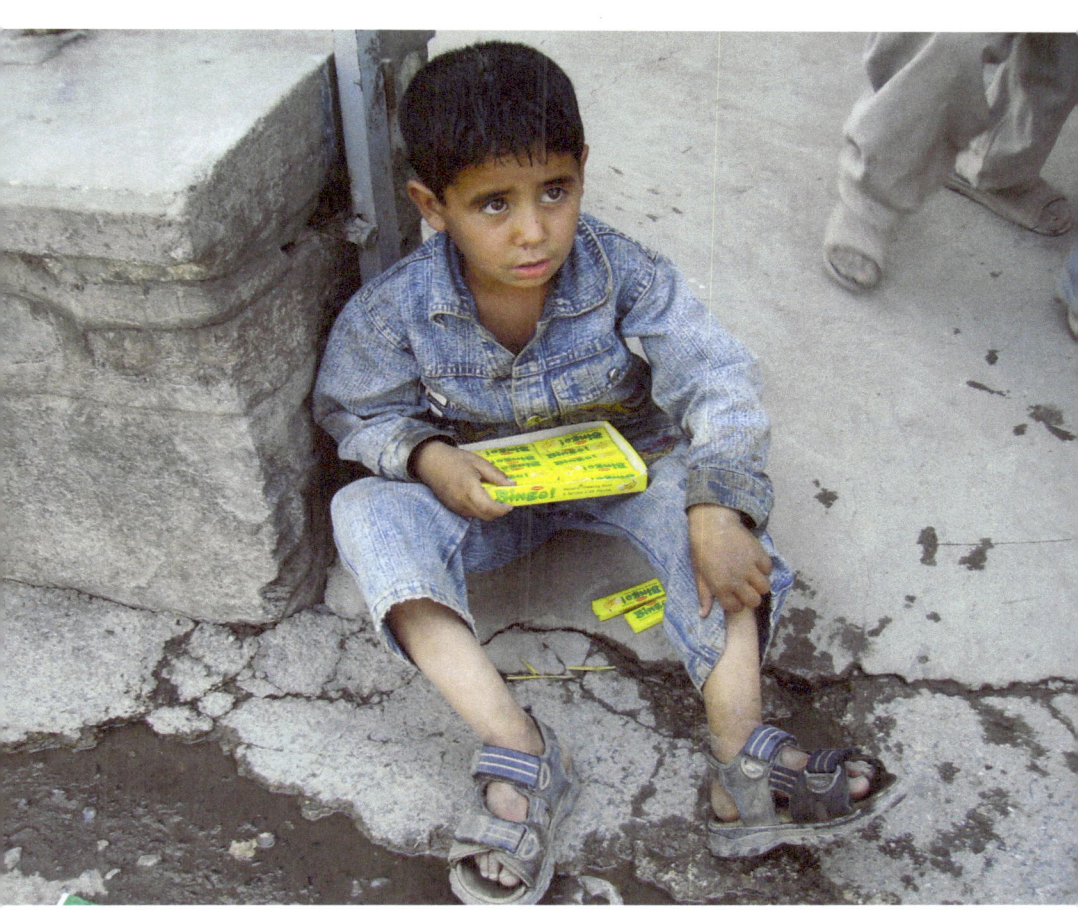

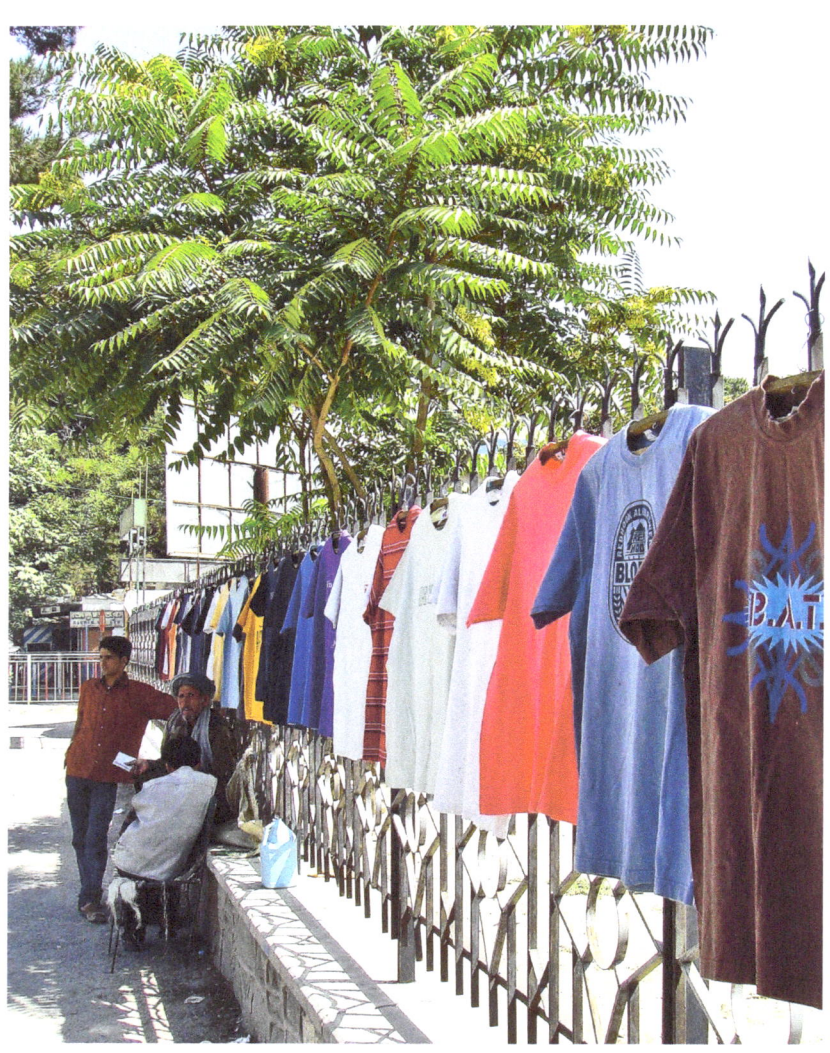

Photographs by
Student #10

Portrait of the photographer.

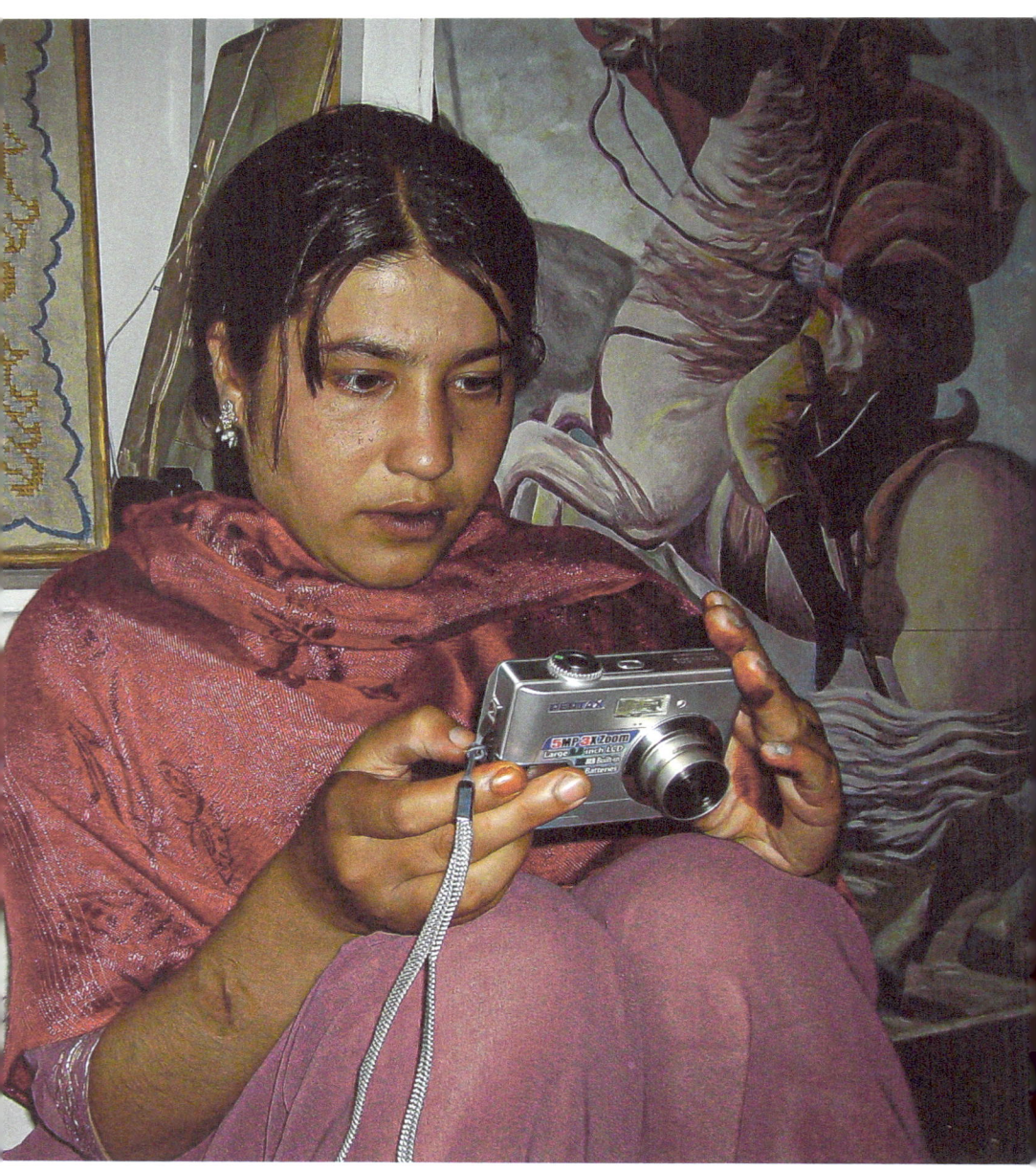

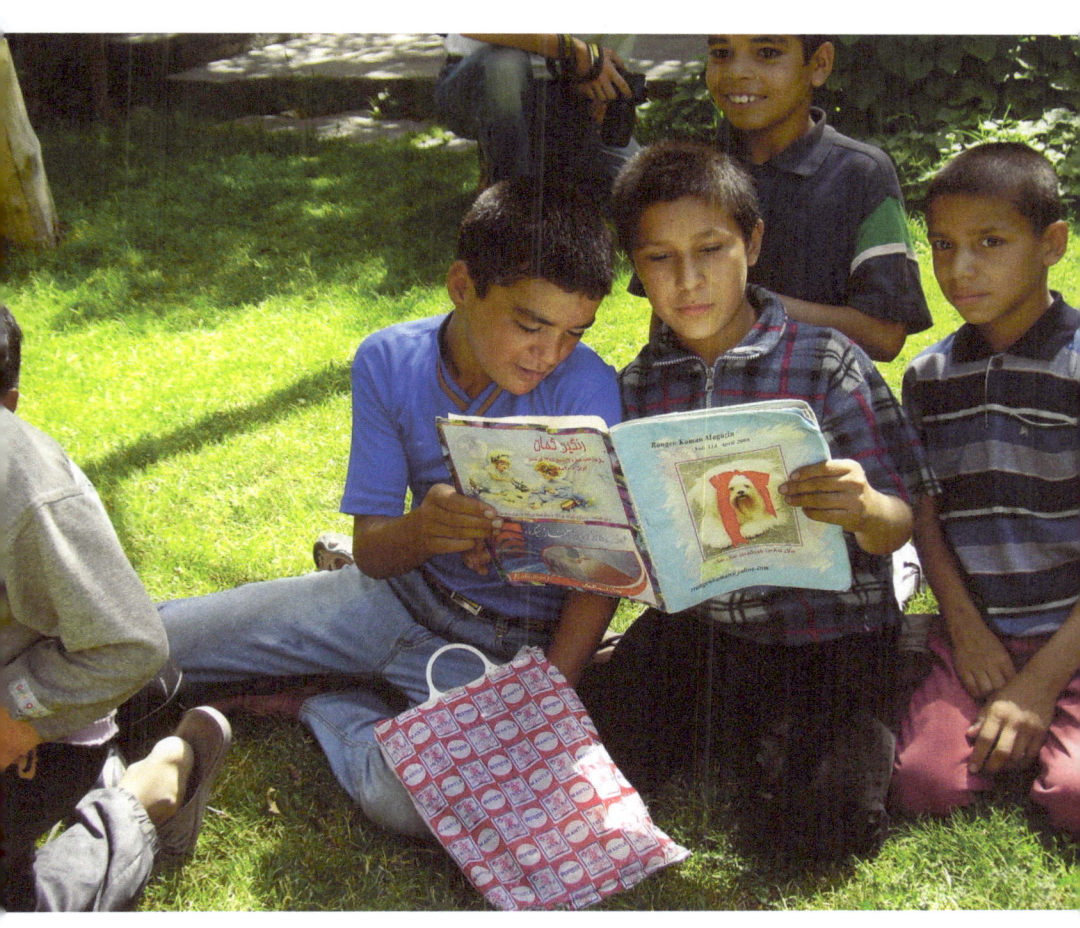

Photographs by
Student #11

Portrait of the photographer.

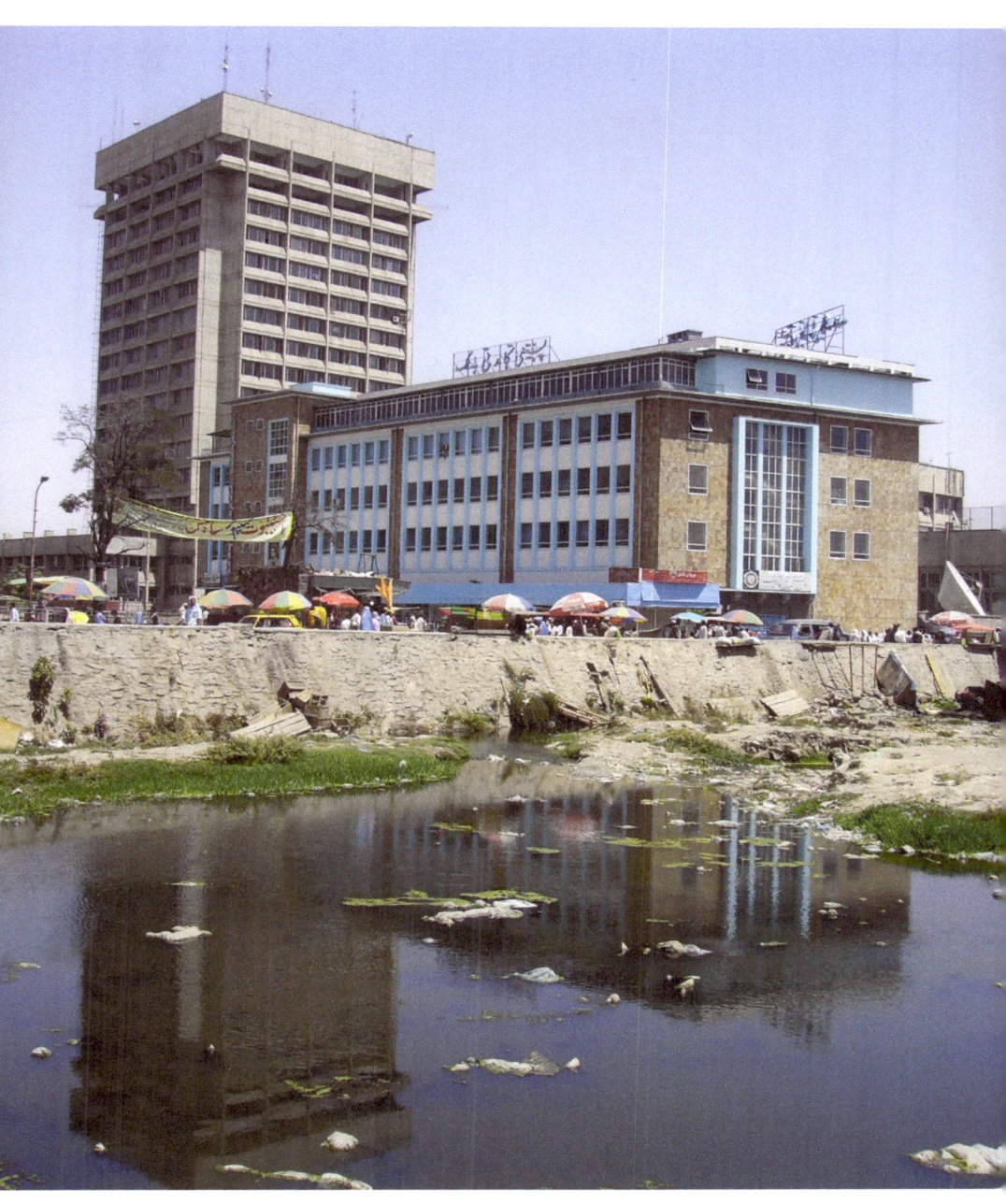

Photographs by
Student #12

Portrait of the photographer.

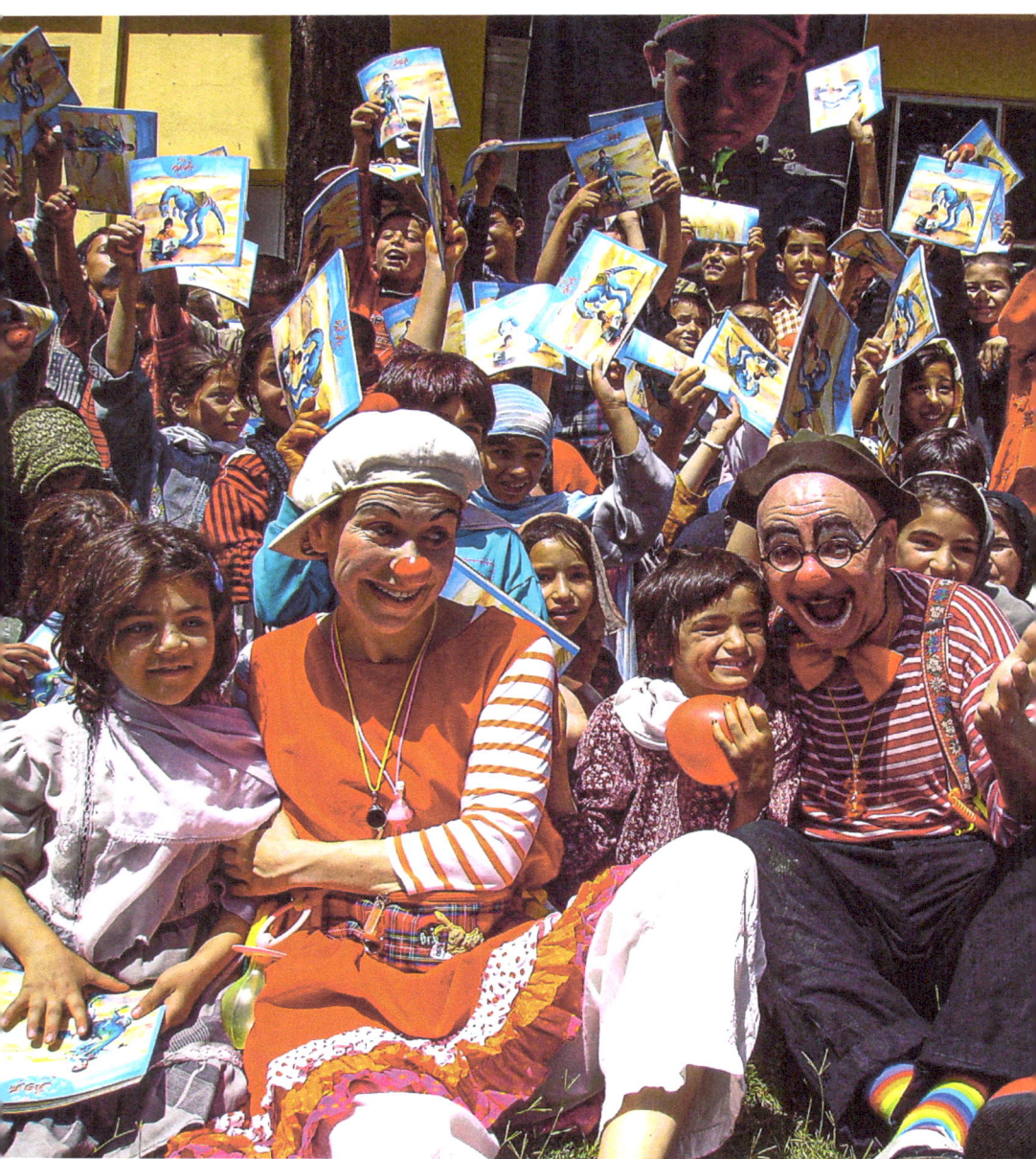

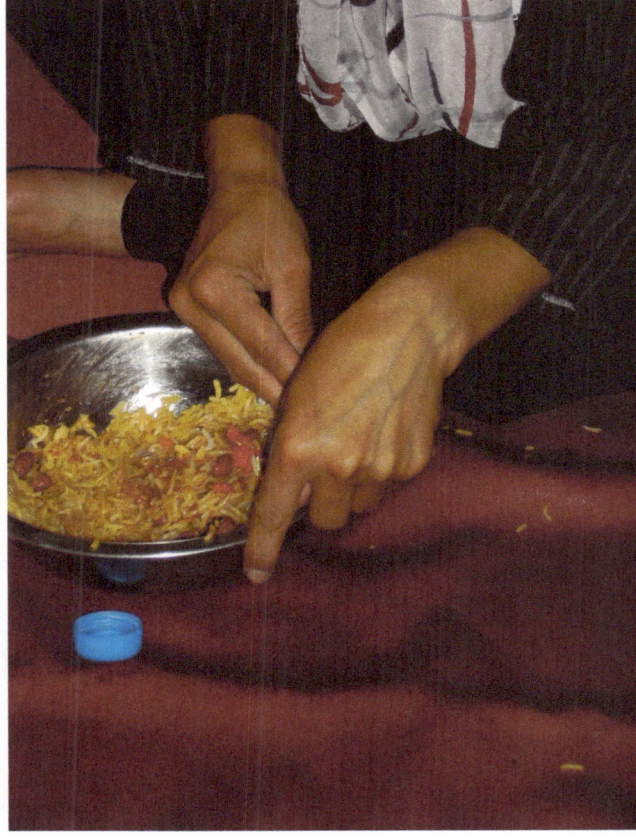

Photographs by the Afghan Students

Photographs by
Student #13

Portrait of the photographer.

Photographs by the Afghan Students

Interview with S. I.

Many of the students had similar life ways as one would suspect. Usually missing one or both of their parents, they were forced to work the streets to provide some income for the family. S I. was something of an exception in that he was older, a university student, and most importantly, spoke and wrote in English. Because of this, I was able to get a more complete interview which was later supplemented with our ongoing email correspondence. Still, his life mirrored the others in many important respects, especially regarding the importance of the American presence to protect against the Taliban.

 S. I. was born in Kabul on November 3, 1986, and started school in Kabul when he was seven years old. By the time he reached the sixth grade, the Taliban occupation had encompassed Kabul, and after a few months there, the family left and went to a relative's home in the northern part of Afghanistan. It was not long before the Taliban also occupied Mazar-i-Sharif, and the family traveled to Peshawar in Pakistan, where they remained for four years until the end of the Taliban rule. While S. I. was in Pakistan, he discovered his interest in photography. Strangely, at that time, he knew little about his native country. He only remembered his hometown of Kabul. He saw a program about an Afghan girl, Sharbat Gull, on the National Geographic channel. Seeing the program stimulated his interest in learning about Afghanistan, and he begin reading and watching films as well as watching BBC and CNN news programs. By this time, S. I. was in the ninth grade, and the family returned to Kabul where he graduated from high school.

 S. I. was determined to become a professional. After he passed the university entrance exams, he enrolled in the fine art school. He wanted to study journalism but didn't pass the entrance exam for that subject area. Fine art was his third choice of study. When he arrived in my class, he was in his second year, having taken courses in English language, mathematics, and various computer classes. All of this took place amid serious fi-

nancial problems within the family and within the country. His father was formerly head of a state department for exports and imports for northern Afghanistan. When the Taliban came and the fighting started, he lost his job and the family left for Pakistan. Now he is jobless and stays at home. His mother doesn't have a job, either.

At the beginning of his first year at the university, a group of Austrian photographers came to hold a workshop in photography, and his interest was rekindled. He sought additional opportunities. He attended various workshops, and he set his sights on becoming one of Afghanistan's most famous photographers.

I asked him why he wanted to do this. He thought about the question for a moment or two and then responded.

I want to express or introduce Afghanistan and the Afghan people to the world through my photos. Afghanistan is like other countries: beautiful as citizens of each country think of their own . . . and [we] want to see it free of interference from other countries who send terrorists to Afghanistan. I want the world to know that Afghan people are not Al-Qaeda or terrorists or suicide bombers. Afghan people are those who have a five-thousand-year-old history. It is the enemies of Afghanistan who take hostages or kill tourists and foreigners to give Afghanistan a bad name and damage our history and hospitality.

As I did with each of the students, I asked S. I. what message he would like for me to give the people of the United States when I returned.

"Most of the Afghan people," he said, "are not educated and don't have any information about the political situation in Afghanistan and don't think of improving and developing their village, city, or country. They have old minds and ideas. If they had any idea about the benefits to their country, they would eagerly accept any country's donation, Muslim or non-Muslim, and start to build Afghanistan and improve their own lives. The open-minded and educated and the youths are optimistic that Afghanistan will improve [with the help of the significant support of the American people] and develop much more in the decades ahead and will be the next Turkey. I want the US Government to stay in Afghanistan and fight with the Afghan people against the enemies who want to destroy us."

S. I. observed that this was not the first time that enemies of Afghanistan have trained and supported terrorists to fight against them. He sincerely hopes that the American people understand that Afghans are no enemy of America. "In Islam," he said, "there is no permission to fight against non-Muslims unless our territory is attacked." I welcomed his more modern understanding of the scriptures.

Comments from Sarah Johnston

The day I started work at Aschiana in 2006 I met some young Austrians who had just completed a three-week workshop teaching a group of Aschiana street kids and some Kabul University students (ages fifteen to twenty-five) the basics of photography. One was interviewing Mohammed Yousef, the head of Aschiana. She told me about the exhibition of photos at the university and the program IPSUM (Austrian group of volunteers) had just run and invited me to visit, which I did.

As part of the course the students had learned how to use a pinhole camera and produce black and white images and then moved on to color photography using a basic film camera. Each participant had chosen a number of images that were printed. They were responsible for mounting and hanging the exhbition themselves. The mounting was pretty haphazard, but some of the images were quite powerful and moving. I was extrememly interested and impressed with the fact that both boys and girls had participated, and that the participants came from both a street kids program and the most prestigous university in the country. The whole project caught my interest and imagination.

The same students also approached Mohammad Yousef and asked permission for a follow-up exhibition to be held at Aschiana's head office in Sare-e-Now. They were very excited and motivated by their experience. Mohammed Yousef and I agreed that I would work closely with them and assist them all to have a follow-up exhibition where they could promote and sell their prints. Two student coordinators were chosen to represent and coordinate the exhibition, one boy and one girl.

As a result, nineteen young photographers participated in the exhibition from the university and Aschiana. Between fifty and seventy people attended the opening on May 11, and more than two hundred adults and children visited the exhibition over the three days that it was open, with approximately eighty children (from other centers) and their teachers and mothers visiting.

Understandably, following the success of this exhibition the students were very keen to develop their skills further. So we started thinking about what we might do next. At the time, I was living in a very large house that housed many of my husband's colleagues working the "counter-narcotics project." As with many companies and organizations with projects in Kabul, consultants and expats were often housed together, rather than in separate hotel accommodations, and relied on dinners and parties for entertainment. One evening there was a party on the top floor, which was actually an open rooftop, so a great space, though rather dark and hard to see who you were talking to. Other project personnel were invited, as well as some British and American Embassy staff. I don't remember who introduced us, but at some point I was introduced to J. B., who mentioned that there was an American photographer who had expressed interest in coming to Kabul. I told her about the photography workshops and exhibition and how we were keen to run a follow-up workshop to build the young photographers' skills. J. B. and I agreed to keep in touch, and not long after I was introduced to Bill by email, and the rest is history. We have been corresponding ever since!

Reflections

The week passed quickly. The warm temperatures of west Texas had certainly prepared me for the hot Afghanistan climate, although only my hotel had air-conditioning. I did sleep well at night. The students were quick to learn, and by the end of the week had amassed over a thousand photographs that ranged upward from basic to excellent as the days progressed. The student photographs would become part of a traveling exhibition scheduled to open at Texas Tech University and then travel to venues across America.

The students were uniformly courteous and attentive, and as the week progressed, more and more comfortable with my presence. They were artistic, like Americans. They laughed and teased as easily as American students do, but they seemed more focused on the work and less on other things. They were "after it!" When I conducted my one-on-one interviews, I found they had very similar backgrounds: large families, one or both parents missing or ill and dependent on their work to help support the family.

The students were very much in love with art. Until I asked them not to do so, they wanted to photograph other artists' paintings because they thought them beautiful. I wanted them to express their own visions, not someone else's. I believe their appreciation for art is a cultural trait, just as their apparently universal appreciation for poetry is. Almost all of them could name a favorite poet and quote portions of the work. The attitude of the students differed from a like grouping of American students. They were more serious. There was little horseplay, and everyone was intent on learning all I could teach. They helped each other with learning the camera controls and in following the instructions I delivered.

They were scared of our military and the news reports of so many Afghan deaths as our soldiers pursued the Taliban. They were appreciative of American support of their country, but had no idea where the money sent from America went. Most thought it was lost due to corruption in the political system. There was a palpable fear that the Taliban would return,

and things would return to the grim days before the US invasion. The last thing they said to me was, "Don't leave us!" I was honored to be with them.

The Photographs

The more I looked at the student photographs, the more I saw in them. Looking at them all together made me realize that 90 percent of them had a person or persons represented. There were very few landscape/architectural subjects unless people were involved. I don't think this was a cognitive decision. I believe the students had been surrounded by people all their lives. They saw the people as their country more than the physical surroundings. Their buildings, streets, and electrical grid had been greatly ravaged by twenty-five years of war. There was little in the infrastructure of the country to be proud of, and the students, living in the city, had little access to the incredible beauty of the countryside.

Technically, the greatest problem the students had was not vision; it was keeping the camera steady and the subject in focus. Many otherwise excellent image ideas had to be discarded because of this. Much of it could be attributed to excitement. They were shooting cameras like the automatic weapons many young Afghans were so familiar with. Of course the older students did better at this than the young ones. They were more contemplative. And they will all get better with practice. Many of the students had had art courses prior to my arrival, so their concept of composition and framing was better developed than I would have supposed.

It was perhaps logical that their favorite subjects were themselves. When the cameras were handed out, they immediately turned to the person next to them and took a picture. They usually traveled around the city in small groups, and often they would photograph one another in different locales and situations. In the editing process for this book, I tried to present as wide a range of information about Kabul and the student's visions as possible. Because the older students ranged wider and had more resources at their disposal, they had more photographs selected, but each student is represented in the book with at least one or two images.

The Country

Afghanistan is terribly backward, even by third world standards. The country has the third highest infant mortality rate in the world. Many if not most of the citizens have no education. What little many have comes

from religious schools. Devastated by repeated wars, the country's electricity is spasmodic, the streets unpaved, the infrastructure crumbling. The country exists, however, because the people are survivors. They have met adversity and have managed to wrestle it at least to a draw. Still, the people I met were very friendly to westerners, or at least to me. The teachers in the school, the shopkeepers, the staff in restaurants—all were uniformly polite and happy to serve me or help me in some way.

Politically, they all are influenced by the Arab press in their hatred for Israel and for our support for it. They view Israelis as invaders who have wrestled land from its legitimate owners. This contributes significantly to the current hatred of things Western by Arab countries. When I was in Dubai, the newspaper headline shouted "Nasrallah: US pushing for Lebanon war to rage." In the body of the paper, they wondered why Americans couldn't understand why they [Arabs] hated us. The article stated, "Karen Hughes was to improve the image of the United States in the Arab world and win the hearts and minds of Arabs that has been lost for some time because of Washington's blind support of Israel and invasion of Iraq. With Washington's support of the Israeli war on Lebanon, Hughes's job was indeed mission impossible."

The more educated and tolerant of the Muslim population seem to have a slightly different perspective on the Israeli conflict. They observe correctly that there were Jews living in the area of Palestine for hundreds if not thousands of years, and there was a peaceful relationship between them and the Arabic population. It was only when the Zionist movement gained full force and began taking Palestinian property and forming a nation that the conflict reached critical levels. Zionists sowed the seeds of the conflict even before the fall of the Ottoman Empire. This conflict has a long, long history and will not be solved in my lifetime.

Other negatives are our culture and religion, although our culture is pervasive in Arab countries. Everywhere are western T-shirts and music, MP-3 players, and internet cafes. They have absorbed our technology, and the fundamentalists hate us for it in a blanket condemnation of the west and our materialistic culture. This hatred is created and nurtured by the Mullahs who preach constantly of a return to the basic life, as structured by the Koran. Although they are happy to do business with us, this attitude lies under the surface everywhere. Not surprisingly, the ethics of Islam do not seem to play out everywhere in the culture. Just as in Christian and Jewish societies, not everyone is ethical. Corruption is rampant.

The urban areas of Afghanistan such as Kabul are as different from the mountain tribal areas as Kabul is from a modern western city. The ultra-conservative tribal customs are difficult to break, but even more difficult for western minds to comprehend. An example provided by an

American health-care worker is instructive. I quote his letter to me:

> We had lunch with a relatively new friend the other day, a Scotsman and a fine man & a few years older than I, he's been here about 3 years with his wonderful wife. He's full of life, energy, and positive expectations. He's been a real encouragement to me.

We were discussing some of the work he's done here [in Afghanistan] and he mentioned that he'd learned some hard lessons; when prompted, he relayed this story.

He, along with his organization, was working in a healthcare project in the region of Badakhshan, which is in the northern section of the nation. This is the province of Afghanistan that reported the highest maternal mortality (death of mother in childbirth) ever recorded. (At that time, one of every six women giving birth in that area would not survive the delivery. I'm glad to say the rate is much better now, but accurate statistical counts are few and far between.) Among other solutions they were pursuing, they were identifying and providing prenatal care to high-risk obstetric patients, women who were pregnant and had some health factors that made them a higher risk for complications than other pregnancies. Due to the difficulty of transportation from this remote area (hiring local men to carry the patient on a stretcher for two days to the nearest road where a vehicle could bring the patient the rest of the way) to a qualified person to deliver the mother, the organization decided to provide funds for the husband to hire the stretcher bearer team to take his wife to a hospital that could provide the needed level of care.

Sounds logical.

So, the organization did just that, they provided funds, about $60 USD equivalent, to the husbands of the three women who were identified as high-risk pregnancies. All of the couples did the same thing. They returned to their homes; then with the money in hand, the husbands let their wives go into labor, and ultimately the mother and baby died. Then, presumably unconcerned, these men simply used the money provided by the well-meaning organization to buy a new wife.

All three women and babies died; all three men bought new wives. The $60, he learned, was more than enough to buy a new wife in that area. A hard lesson. A tragic loss of life, but a revealing truth about the culture.

This mentality is not universal, but the true story serves to explain the primitive level of society in much of the isolated, tribal areas of the country. Concerns are personal preservation and tribal loyalty, and women are property to be disposed of at will. In Dubai and other more modernized Arab countries, the culture is quite different.

The United States Department of State

I have had several opportunities to work with representatives of the United States Department of State. Some in our country decry their actions as ineffective and weak. I find the contrary. Our employees overseas have been uniformly enthusiastic about their jobs and eager to represent our country to the best of their abilities. They have shown compassion and support for the host country and operate under appalling conditions in many parts of the world. They deserve our gratitude and respect. Unfortunately, because of misguided political direction, the expertise they develop regarding other countries and cultures is often disregarded.

Finally, the trip was very worthwhile in my view. I remember the starfish story, where a man on the beach littered with dying starfish after a storm replied to a suggestion that it would make no difference to toss them back. "It made a difference to that one!" he said as he tossed it back into the safety of the sea. If my visit made a difference to even one of the students or one of the persons I came in contact with while there, it would make it successful. If even one of them related to me as an American who cared enough to come at my own expense to help them, and if that person remembers that we aren't all demons, hateful of Muslims, it would be enough. Already, one has begun a career in photojournalism and is working with a Kabul news agency. I hope to keep in touch with as many of the students as possible, and with Aschiana, to follow their progress.

Epilogue

In 2021, as the Taliban engulfs the country, children are still struggling to eat, and many continue to work the streets in hopes of selling enough gum or wiping enough windshields to help their families survive. There is fear that the extreme religious beliefs of the Taliban will quickly erode the newly secured rights for both men and women. Then a dark cloud of ignorance and superstition would wipe out the fragile gains that so many lives were given to make possible.

In a March 19, 2019, *Reuters* article by Rod Nickel and Abdul Matin entitled "Killed, orphaned, sold: Afghan war takes brutal toll on children," the authors report that "half the population (in this country) is younger than 15" and that the then "17-year war has arguably hit children the hardest." They continue to note that in addition to "some 927 children...killed last year...a growing number of children (are) orphaned or forced to work in the streets." This is the Kabul I encountered in 2006.

Aschiana, the charity organization that welcomed me to teach digital photography, receives mention: "Aschiana has seen the number of Afghan children at risk rise sharply in recent years." Sale of children for the survival of the rest in a household continues. For more heartbreaking details go here: https://www.reuters.com/article/afghanistan-children-idINKCN1R1026.

Acknowledgments

There are many people whose contributions made this project possible. First and foremost, Richard Baltimore, formerly United States Ambassador to Oman, who suggested I be contacted regarding the project. J.B. Leedy, the embassy Public Affairs Officer in Kabul, got excited about the potential, and without her support, enthusiasm, and the Department of State's purchase of the digital lab equipment, it would not have happened.

In Kabul, the marvelous Sarah Johnston not only was the original instigator of the project, she was invaluable in its execution, working steadily each day handling the details and helping organize the classroom logistics. My Afghan "fixer," F. H., was my driver, interpreter, and my daily companion whose friendship I treasure and will always count among my most enduring.

Of course, no project happens without funding. While I was able to contribute my personal expenses, a wide range of friends wanted to participate. Without their financial support to purchase the digital cameras and supplies, the task would have been insurmountable. Many thanks to Linda Abel, Bob and Peggy Beckham, Chuck and Lisa Bowman, William Bradshaw, Ralph and Ann Bridwell, Frank Calhoun, Jerry and Jo Ann Clark, Molly Cline, Owen Cook III, Henry Doscher Jr., Jerdy and Anne Gary, Michael and Leann Gillette, Nancy Hamilton, Sally Hoffman, Eleanor and Robert Hoppe, Bennie and Diane Jones, Maj. General Robert and Shirley Marquette, Erik Mason, Jack and Joy Mergele, Jon and Sandra Moline, Ken and Noel Moore, George and Tootsie Nichols, B.A. and Eloise Pearl, Milton and Ann Rowley, Nancy Scanlan, Bill and Lila Senter, Judge Bea Ann Smith, Dan Sorkin, Jo Allan and Cynthia Steph, Lonn and Dedie Taylor, Jimmy Tittle, Mack and Sharlene Turley, James Veninga, John Whitney, Jeanne Williams, and Koichi Yasutani.

I am most grateful to Marcia Hatfield Daudistel, who generously reviewed the manuscript and suggested helpful changes. Thanks go also to Rick DeFoore, who assisted my conveyance to a hospital in Kabul when I injured my back. Most of all, I give thanks to Marianne Wood, who assisted in the current revision of the manuscript. I am grateful to TCU Press for printing this updated account of my Afghan experience. Finally, my gratitude to my wife, Alice, and our family, who endured my trip to Afghanistan in the midst of a war with anxiety and concern, but who gave me their blessing when it was obvious that I intended to make the trip.

About the Author

For thirty-five years, Bill Wright owned and managed a wholesale and retail petroleum marketing company. In 1987 he sold his company to his employees. Since then, he has devoted his time to writing, photography, and serving on many commissions and boards, including the National Council for the Humanities, Humanities Texas, and the Texas Commission on the Arts.

Wright started photographing as a student in high school and participated in Ansel Adams's last Yosemite workshop, which he credits as the turning point of his photographic life. Wright's photographs are in the collections of many private individuals and institutions, including the Amon Carter Museum of American Art in Fort Worth, the Museum of Fine Arts, Houston, the Wittliff Collections at Texas State University, San Marcos, the El Paso Centennial Museum of the University of Texas at El Paso, the Harry Ransom Humanities Research Center and the Dolph Briscoe Center for American History, both at the University of Texas at Austin, and the Smithsonian Institution in Washington, DC. His work has received many awards, including the Leica Award of Excellence and the Border Book award. He is the writer/cowriter and photographer for many books, as noted in the opening pages of this book.

Please visit his website: wrightworld.com.

 CPSIA information can be obtained
at www.ICGtesting.com
Printed in the USA
LVHW070007221221
706786LV00001BA/2